IMAGES
of America

HURRICANE HAZEL IN THE CAROLINAS

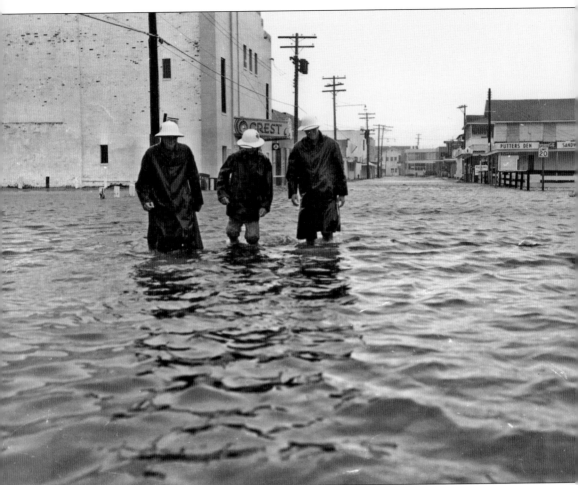

Three Red Cross officials wade along Lumina Avenue in Wrightsville Beach, North Carolina, just hours after the passage of Hurricane Hazel. Most of the town's interior streets were underwater during the storm. Souvenir shops, restaurants, and the old Crest Theater were flooded. Hazel's storm tide on Wrightsville was the highest in the memories of island residents. (Courtesy of the *News and Observer*.)

ON THE COVER: An unknown girl wades through knee-deep water covering Harper Avenue in Carolina Beach, North Carolina, after Hurricane Hazel's passing in October 1954. This photograph was among those taken by well-known Tar Heel photographer, promoter, and conservationist Hugh Morton, who was on the coast to cover the storm. (Courtesy of Hugh Morton.)

IMAGES
of America

HURRICANE HAZEL IN THE CAROLINAS

Jay Barnes

Published by Arcadia Publishing
Charleston SC, Chicago IL, Portsmouth NH, San Francisco CA

Printed in the United States of America

Library of Congress Control Number: 2009936095

For all general information contact Arcadia Publishing at:
Telephone 843-853-2070
Fax 843-853-0044
E-mail sales@arcadiapublishing.com
For customer service and orders:
Toll-Free 1-888-313-2665

Visit us on the Internet at www.arcadiapublishing.com

*This book is dedicated to the men, women, and children
whose lives were lost to Hurricane Hazel
and to those who survived the storm to share their stories.*

CONTENTS

ACKNOWLEDGMENTS

I grew up in Southport, North Carolina, near the epicenter of Hurricane Hazel's impact on the Carolina coast. Though Hazel struck a few years before I was born, it left such a lasting impression on my family, friends, and neighbors that I remember hearing stories about it all through my youth. As a teenager, I became fascinated with hurricanes and began collecting photographs and news clippings about Hazel and all the other storms that affected our region. So first, I would thank my parents and our friends in Southport and Oak Island who helped spark my interest in this subject.

This book would not have been possible without the amazing photographs provided by a wide variety of individuals, newspapers, museums, libraries, and government agencies. These individuals and groups were generous in their support of this project, and I am extremely grateful for their assistance. Notable among these are the late Hugh Morton, whose stunning photographs are true treasures; the late Jerry Schumacher, whose Morehead City photographs add much to these pages; and the late Art Newton, a prolific photographer who captured Hazel's destruction and then published his images for all to see. These three North Carolina photographers are well represented in this book.

Many other individuals and their families are to be thanked for giving me their time and providing photographs and/or assistance, including Keith Barnes, Merlin Bellamy, Guy Cox, Kim Cumber, Al Creasy, Bill Creasy, Mr. and Mrs. John F. Davis, Barbara Fowler, Jim Gifford, Alice Graham, Clifton Guthrie, Lewis Hardee, Roy Hardee, Ed Harper, Jim Harper, Barbara Horner, Terri Hudgins, Elizabeth King, Gloria Lance, Keith Longiotti, LuAnne Mims, Pete McSorely, David Montgomery, Suzanne Paradis, Lockwood Phillips, Walter Phillips, Leila Pigott, Julie Pinkney, Gordon Powley, Martin Proctor, Clyde Roberson, Punk Spencer, Barbara Stokes, Beverly Tetterton, Sarah Whittington, and Cathy Wiggins.

Thanks also go to the organizations whose collections contain many of these images: the American Red Cross, the Archives of Ontario, Brookgreen Gardens, Brown Library, Carteret County Historical Society, Cape Fear Museum, Chapin Memorial Library, Horry County Museum, New Hanover County Library, North Carolina State Archives, Raines and Cox Photography, Temple University Archives, the History Place, U.S. Air Force, U.S. Army Corps of Engineers, National Oceanic and Atmospheric Administration (NOAA), University of North Carolina Library at Chapel Hill, Wrightsville Beach Museum, Weston Historical Society, the *News and Observer*, the *State Port Pilot*, and the *Carteret County News-Times*.

INTRODUCTION

Over the years, the Carolinas have seen more than their share of tropical storms and hurricanes. This legacy stretches back through the centuries to a time when early colonists endured punishing storms that washed away settlements and sank hundreds of ships in the "Graveyard of the Atlantic."

Devastating hurricanes made landfall here in recent decades too, like Hurricane Hugo in South Carolina in 1989 and Hurricanes Fran and Floyd in North Carolina in the late 1990s. Each of these disasters delivered billions in property damages, caused scores of deaths, and became new benchmarks in the weather history of the region. They are the hurricanes that a whole generation of survivors will talk about for years to come.

But before there was a Hugo, a Fran, or a Floyd, there was another great storm that was always first to be mentioned whenever the subject of hurricanes was discussed. In North and South Carolina, the stories always began with "I remember Hazel."

Hurricane Hazel, which came ashore near the South Carolina–North Carolina border on the morning of October 15, 1954, was more than just a swift punch to the Carolina coast. It was truly one for the record books, for its sheer size, power, and endurance. It was an epic storm in each place it visited, from the hillside villages of Haiti to the riverside suburbs of Ontario, Canada, and everywhere in between. To this day, Hazel still ranks among the top 25 on each of the National Hurricane Center's three superlative lists: the deadliest, costliest, and most intense hurricanes to strike the United States. And for thousands of unprepared residents of the Carolinas, it was absolute disaster.

During the 1950s, while most of America was laughing at Milton Berle, rockin' with Elvis, or worrying about Khrushchev and the bomb, the people of eastern North and South Carolina were grappling with hurricanes. Hazel was just one of a string of violent storms to blast the Carolinas during the decade; each was given a ladies' name, a practice begun in 1953 to differentiate storms from each other. They arrived during a time when there was no National Hurricane Center, no satellite reconnaissance, and no Weather Channel. Forecasters could not easily predict storm movements, and news media were not particularly focused on the threat of hurricanes. As a result, communities that lay in the path of storms like Hazel often had little or no time to prepare.

Hazel's journey across the hemisphere began when it was first spotted deep in the Caribbean near Grenada on October 5. It was soon tracked moving west-northwest through the Grenadines. Winds were clocked at 95 miles per hour, and the small island of Carriacou was the first to suffer from Hazel's winds and tides. The growing storm continued to draw energy from warm Caribbean waters and intensified as it curved northward. On the morning of October 12, it slammed into the Haitian coast and quickly became one of the deadliest Caribbean hurricanes of the century. Heavy rains caused massive landslides that buried mountain villages, killing hundreds of unsuspecting Haitians. In all, the death toll there was estimated at nearly 1,000.

In Miami, the Weather Bureau's chief forecaster, Grady Norton, was terribly concerned about the storm. Norton was a seasoned veteran who was experienced with unpredictable hurricanes,

and he alone was responsible for preparing updates on Hazel. As the hurricane spun toward Haiti, Norton worked into the night, monitoring reports and tracking the storm. Unfortunately, he died of a stroke during this time, leaving all forecasting duties to his young assistant.

Though it had weakened considerably as it swept over the rugged Haitian mountains, Hazel quickly regained strength as it moved northward over warm Bahamian waters. After crossing Haiti, it was thought the storm might pass offshore along the U.S. coast. It was not until later on October 14 that it became obvious Hazel would strike the Carolinas. By 8:00 a.m. on Friday, October 15, the storm's eye was just 95 miles east of Charleston, South Carolina, and its outer fringes were buffeting the coast just below Myrtle Beach. Within hours, Hazel raced ashore as a powerful Category 4 hurricane, with a forward speed of 30 miles per hour and sustained wind speeds of more than 130 miles per hour. Landfall occurred just north of Cherry Grove, South Carolina, around 9:30 a.m.

With landfall came the greatest tidal inundation ever witnessed in the region. Hazel struck on a full moon high tide, which elevated the storm surge even more. Water levels were estimated at 14 to 15 feet along the coast near Myrtle Beach, 18 feet at Calabash, North Carolina, and 17 feet at Long Beach, North Carolina. This record tide swept away hundreds of beachfront cottages, hotels, resorts, and fishing piers over a large portion of the coast. On some beaches, homes were knocked off their foundations and tossed around like toys. Along the hardest hit beaches of Brunswick County, North Carolina, the islands were simply swept clean—few, if any, homes remained standing.

After landfall, Hazel barreled inland and sliced through interior North Carolina while accelerating northward. By the time it reached the Virginia line around mid-afternoon, it was racing forward at nearly 50 miles per hour. It sustained much of its intensity along the way, with Category 3 winds felt as far inland as Raleigh, North Carolina. The inland track caught most everyone off guard. Residents scrambled to safety through the roaring gusts, dodging crashing trees and falling power poles along the way.

But unlike other hurricanes that typically weaken over land, Hazel remained powerful as it churned through the mid-Atlantic states. Wind gusts measuring more than 100 miles per hour blasted Virginia, Maryland, Washington, D.C., Delaware, Pennsylvania, New Jersey, and New York. Some of those wind extremes includes gusts of 100 miles per hour in Norfolk, Virginia; 98 miles per hour in Arlington, Virginia; 101 miles per hour in Salisbury, Maryland; 100 miles per hour in Philadelphia, Pennsylvania; and 113 miles per hour in New York City. Several of these records still stand today.

Hazel's sprint northward included monsoon-like rains that were heaviest on the western side of the storm. Up to 12 inches fell across portions of West Virginia, Pennsylvania, and western New York state. As the storm passed through New York late on October 15, it interacted with a strong low-pressure system coming off the Great Lakes to produce even more rain. The results were directed on Hazel's next victims—the unsuspecting residents of Ontario, Canada, whose homes and cars were swept away by flash floods. Hazel's arrival during the night was devastating, as most residents were sleeping when the floods came. There were 81 fatalities in the Toronto area, and 1,900 families were left homeless.

From start to finish, the numbers were staggering. In the United States alone, Hazel killed 95, including 1 in South Carolina, 19 in North Carolina, 13 in Virginia, 6 in Maryland, 3 in Washington, D.C., and 11 in Pennsylvania. In North and South Carolina, damages were estimated at $163 million (1954 dollars), with $27 million from the South Carolina coast, $36 million from the North Carolina coast, and the remainder from crop and property damages in the interior portions of both states.

In 1955, the name "Hazel" was retired from the list of hurricane names used by the U.S. Weather Bureau. It was only the second hurricane to have received that distinction.

One

THE APPROACHING STORM

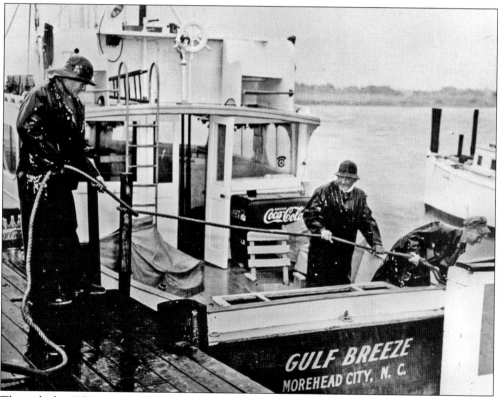

Through the 1950s, a steady barrage of tropical storms and hurricanes swept the Carolina coast. Coastal residents learned to pay close attention to weather reports during late summer and fall and be prepared should a hurricane notice be posted. With each approaching storm, preparations were taken seriously, especially by those who made their living on the water. (Photograph by Jerry Schumacher; courtesy of the Carteret County Historical Society.)

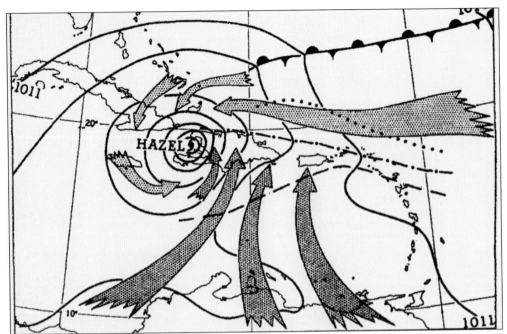

Hurricane Hazel was first detected on October 5, 1954, as a small storm just east of Grenada. Over the next week it strengthened and swept northward, eventually striking the Haitian coast on October 12. Haiti was devastated by high winds and deadly mud slides, some of which swept away entire villages. (Courtesy of National Oceanic and Atmospheric Administration, NOAA.)

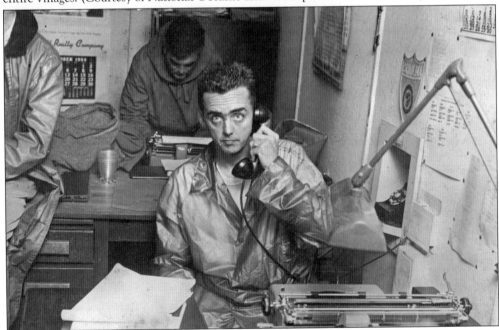

A young mayor Michael Brown of Wrightsville Beach takes a call prior to Hazel's arrival on October 15. Mayor Brown worked with police and other town officials to notify residents of the serious threat posed by the storm. Though the island was flooded, including the police station, no lives were lost on Wrightsville Beach. (Courtesy of Elizabeth King.)

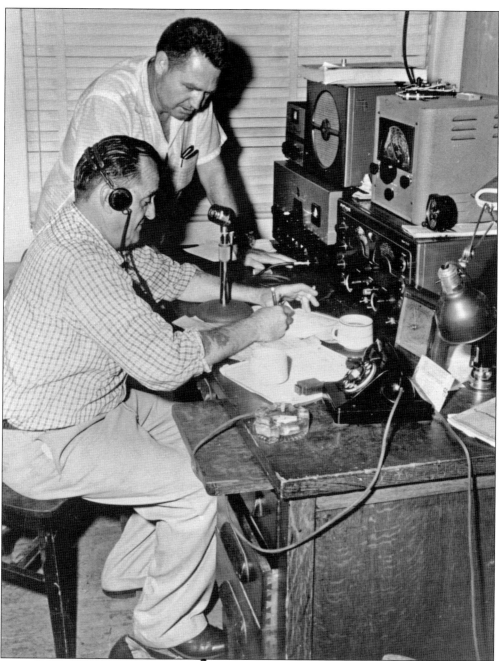

After any hurricane, communications between government officials, weather offices, the media, and the public are critically important. During the hurricanes of the 1950s, telephone lines were often downed, there were no cell phones, and many television and radio stations were not equipped with backup generators. During Hurricane Hazel and other storms of this period, ham radio operators played a critical role in relaying damage reports and recovery information throughout the Carolinas. Hams were often called on by state and local governments to work long hours. (Photograph by Jerry Schumacher; courtesy of the Carteret County Historical Society.)

In preparation for an approaching hurricane, many fishermen choose to relocate their boats to inland creeks that provided safe harbor from damaging waves and high winds. Larger vessels, however, sometimes must weather storms at their docks. This requires careful attention from boat owners to prepare their craft for unpredictable tides, winds, and waves. Along the Morehead City, North Carolina, waterfront prior to Hazel, party boats were lashed with extra long "spider lines" to help them ride out the storm and avoid crashing into their docks. (Photograph by Jerry Schumacher; courtesy of the Carteret County Historical Society.)

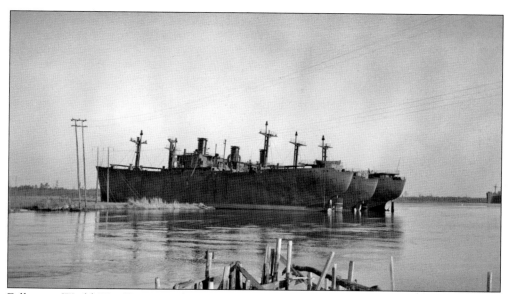

Following World War II, scores of surplus Liberty cargo ships were anchored in mothballs near Wilmington, North Carolina. Hazel's high winds snapped the cables of three ships, sending them upriver to threaten the Brunswick River Bridge. At the peak of the storm, a tugboat captain launched his tug and stopped the ships just 100 yards from the bridge, saving the only concrete span that linked Brunswick and New Hanover Counties. (Courtesy of the Cape Fear Museum.)

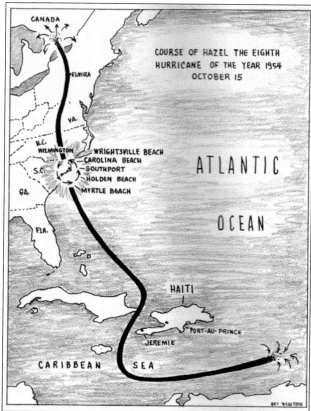

Southport, North Carolina, artist and photographer Art Newton sketched this track map to illustrate Hazel's course northward for the 1955 booklet *Hurricane Hazel Lashes Coastal Carolinas*. Newton also served as editor for the publication, which featured many of the photographs reproduced here. Newton's track map shows the hurricane's path from the Caribbean through the Carolinas and into Canada. (Illustration by Art Newton; courtesy of the Wilmington Publishing Company.)

13

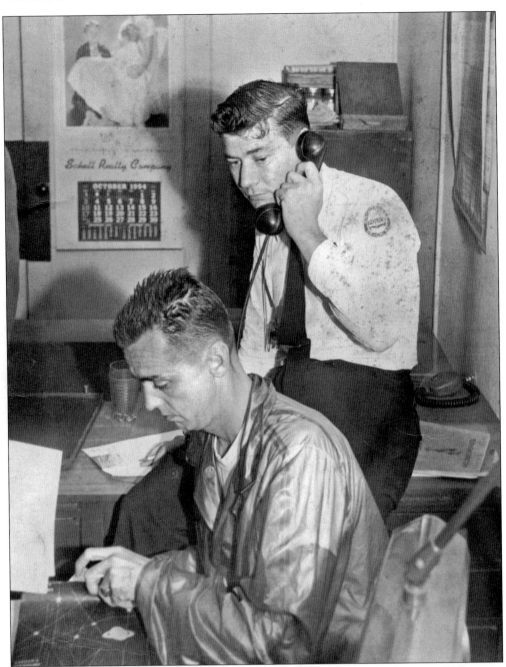

Wrightsville Beach mayor Michael Brown (foreground) and police chief Everett Williamson (background) work together in the town's old police station prior to Hurricane Hazel's arrival. An October 1954 calendar can be seen on the station wall. Though Weather Bureau statements regarding Hazel were issued for coastal portions of the Carolinas, newspapers and radio stations typically did not present the threat with the sense of urgency that was needed. In many coastal communities like Wrightsville Beach, town police were largely responsible for warning citizens to leave the island. Today when a hurricane threatens, local and national media saturate the airwaves with regular updates, offering coastal residents ample warning. (Courtesy of Elizabeth King.)

Two

Hazel on the Carolina Coast

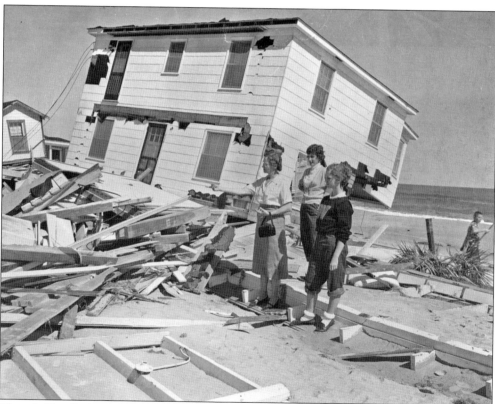

Though Hazel's destructive force was spread across 2,000 miles, from the lower Caribbean to Canada, no place experienced a more dramatic impact than did the barrier beaches of North and South Carolina. It was along the shores of these islands that some of the hurricane's most memorable photographs were taken. These images, most of which were shot just days after the storm passed, offer a solemn testament to the brute force delivered by the hurricane's mighty storm surge. Here a family inspects the destruction of cottages at Carolina Beach. (Courtesy of the Cape Fear Museum.)

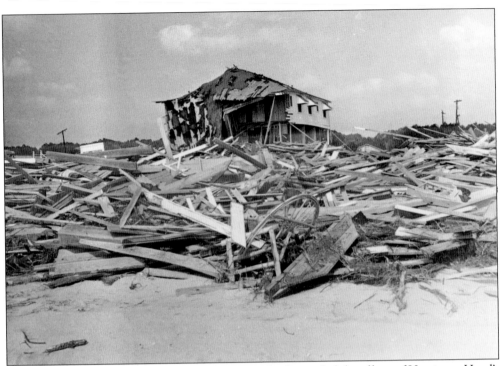

The beaches of northeastern South Carolina were the first to feel the effects of Hurricane Hazel's arrival on October 15, 1954. By sunrise on that day, large breakers were already pounding the shores near Myrtle Beach. At 8:00 a.m., the storm's center passed about 95 miles east of Charleston. About this time, the hurricane's outer rain bands began moving ashore at North Island. Then, between 9:30 and 10:00 a.m., Hazel's eye made landfall very near the North Carolina–South Carolina border. This track placed the resort beaches of Myrtle Beach, Crescent Beach, North Myrtle Beach, and Cherry Grove directly in the path of the storm. The result was disastrous for first- and second-row cottages that lined the shore. (Above and below, courtesy of the Horry County Museum.)

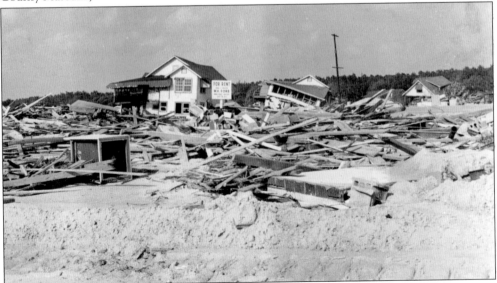

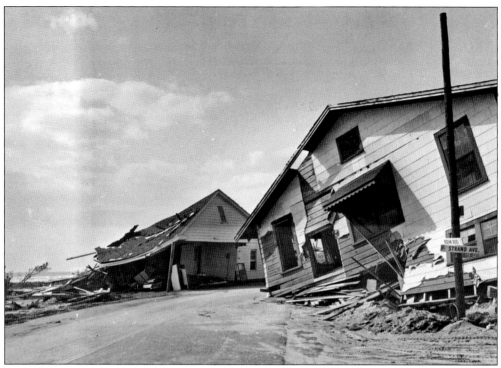

Though Hazel's winds were ferocious, South Carolina's beachfront communities suffered most from the hurricane's rising storm tide and pounding waves. The surge arrived just before the eye and swept cottages off their foundations and away from the shore. Some homes were relocated blocks away from their original positions, while others were reduced to scattered timbers. Areas south of Myrtle Beach, like Pawley's Island and Litchfield Beach, suffered some destruction, but those nearest the point of landfall received the highest storm tide and the heaviest damage. These cottages in North Myrtle Beach were typical of the wreckage seen in the days following the storm. (Above and below, courtesy of the Horry County Museum.)

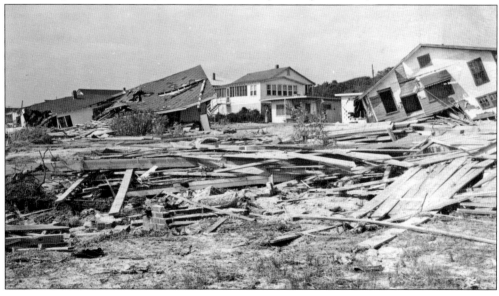

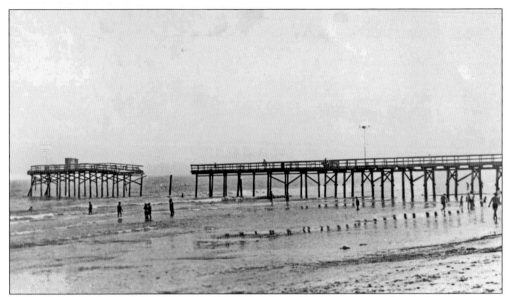

Among the losses along the coast were scores of ocean fishing piers. In South Carolina, every pier north of Pawley's Island was heavily damaged or destroyed. These included the Garden City Pier, Surfside Pier, Myrtle Beach State Park Pier, Second Avenue Pier, Ocean Plaza Pier, Windy Hill Pier, Tilghman Pier, and Cherry Grove Pier. Some were broken into sections, while others were washed away. Most were rebuilt and ready for the 1955 season. (Courtesy of the Horry County Museum.)

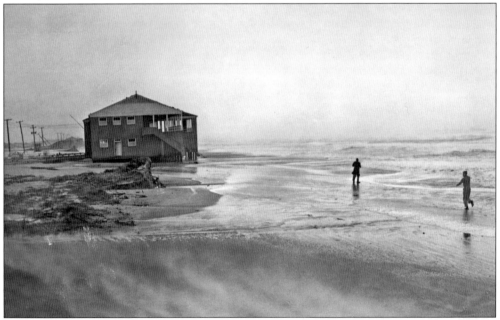

Most all of the oceanfront villas and resorts that lined North Ocean Boulevard in Myrtle Beach were hammered by Hazel's winds and tides. In many cases, it was a one-two punch, with wave action undermining foundations and supporting structures and gusts up to 150 miles per hour tearing down awnings and porches. Homes that were still standing were no longer protected by rows of dunes. (Courtesy of the Cape Fear Museum.)

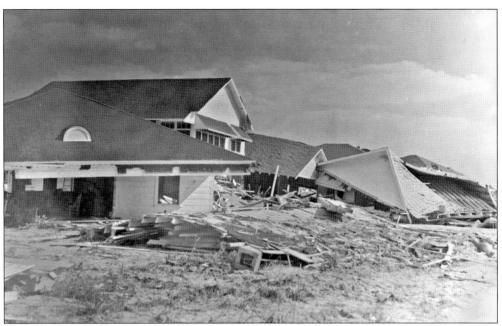

In Myrtle Beach, Red Cross officials reported that 80 percent of the front-row structures were destroyed. A storm surge of about 15 feet was responsible for most of the damage. Many three-story structures were reduced to two, and some cottages simply disintegrated and could not be found. Others were washed across Ocean Boulevard and wound up randomly stacked against other houses. Once the storm passed and residents began to return, many were awestruck with what they found. South Carolina governor James F. Byrnes declared martial law in the area after "extensive looting" of damaged homes was reported. National Guard units were dispatched into the area to guard the hollowed properties throughout the area. (Above, courtesy of the Horry County Museum; below, courtesy of the Cape Fear Museum.)

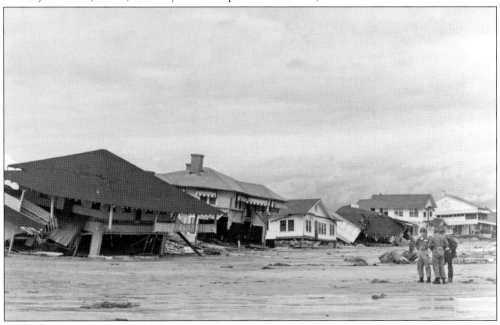

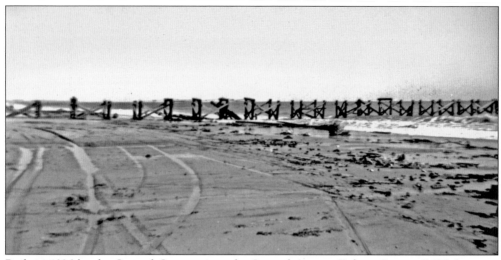

Built in 1936 by the Coastal Corporation, the Second Avenue Fishing Pier, at 2,180 feet, was once the longest fishing pier on the East Coast. It was constructed over a natural underwater rock outcrop, which provided excellent fishing. This photograph shows all that remained of the pier after Hazel. But it was rebuilt afterwards, and today it remains a popular destination for fishing in Myrtle Beach—though its total length is now just over 900 feet. (Courtesy of the Cape Fear Museum.)

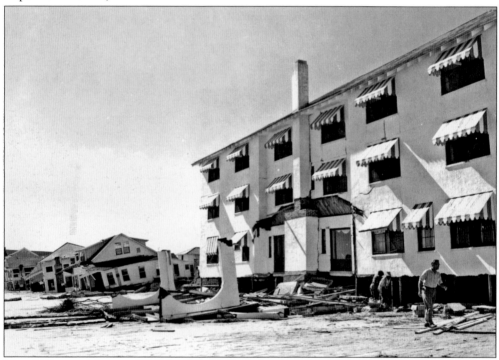

The old Patricia Manor at 2710 North Ocean Boulevard is one of the most storied hotels in Myrtle Beach history. Built in the early 1930s by Pat Ivey, it was perhaps the area's first hotel to target affluent vacationers. Like its neighbors, the old Manor was pounded by Hazel's storm surge, which tore apart the oceanfront portico and flooded the first floor. Today the property is known as the Patricia Grand Resort. (Courtesy of the Cape Fear Museum.)

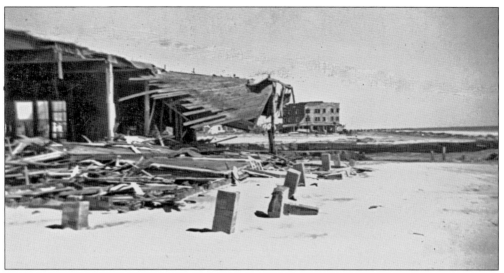

Built in 1941, the United Services Organizations (USO) Recreation Center on Ocean Boulevard South served military families from the nearby Myrtle Beach Army Air Corps Base. During World War II, it featured a dance hall, a restaurant, a bathhouse, and a tennis court. The property was heavily damaged by Hazel's storm tide. It was later sold and reopened as Moody's Court Hotel. (Courtesy of the Cape Fear Museum.)

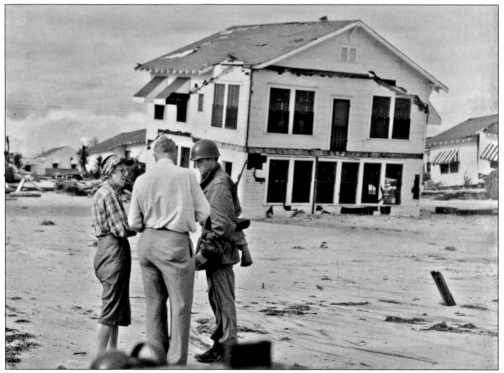

In the days following Hazel's passage through Myrtle Beach, martial law was declared to maintain order and prevent looting in the heavily damaged oceanfront communities. Police, highway patrol, and National Guard troops were stationed throughout the region, and residents returning to their properties were asked to provide proper identification. (Courtesy of the Cape Fear Museum.)

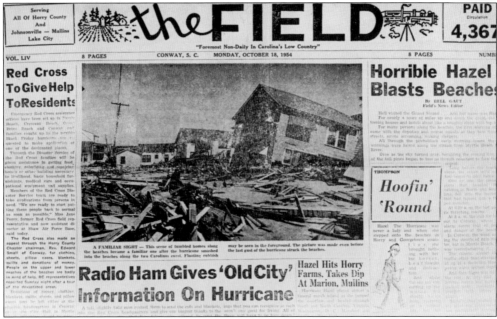

Newspapers across North and South Carolina were filled with stories about Hazel's destructive force in the days after its passing. National media also took interest, especially because of the hurricane's journey through the mid-Atlantic states. Among the local newspapers covering the storm's impact on Myrtle Beach was the *Field*, a weekly from nearby Conway, South Carolina. (Courtesy of the Horry County Museum.)

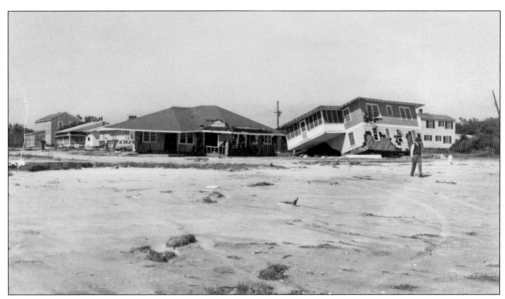

Many of the photographs in this book were provided by local residents who remember the storm. Myrtle Beach resident Barbara Horner recalls the circumstances regarding the cottages in the photograph above: "This photo was taken by my mother on 76th Avenue North in Myrtle Beach. These houses were two stories, and the gray one was oceanfront. The white one was second row. They washed over each other." (Courtesy of Barbara Horner.)

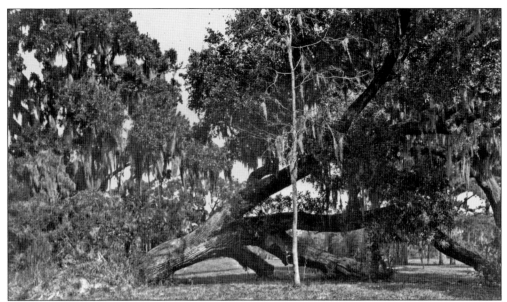

Hazel's wind gusts along the northern beaches of the South Carolina coast likely reached 150 miles per hour, though no official measurements approached that speed. The highest official wind reading was 106 miles per hour, taken at Myrtle Beach Army Air Corps Base. But high gusting winds swirled over much of the region, toppling telephone poles, signs, and thousands of large trees. In Georgetown, South Carolina, Benjamin Johnson was severely injured when he was struck by a large tree, fracturing his leg and spine. At Brookgreen Gardens, massive 300-year-old live oaks and other trees were toppled throughout the property, some nearly damaging the garden's marble sculpture collection. (Above and below, courtesy of Brookgreen Gardens.)

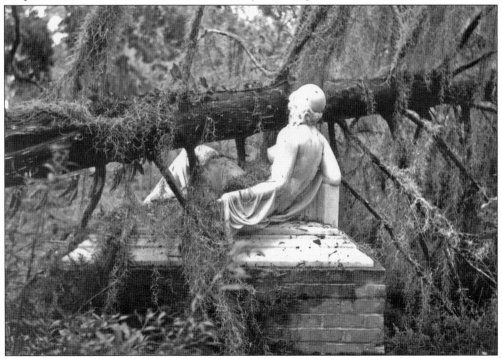

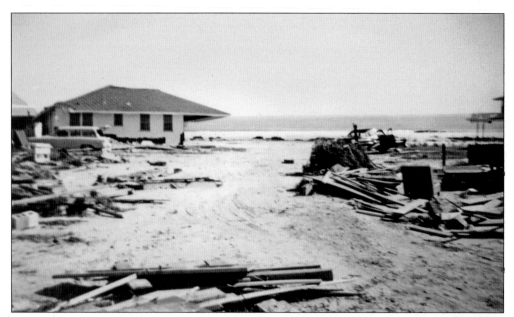

Many of the prominent names in business and industry from across the Carolinas owned cottages in Myrtle Beach during the 1950s. Their homes were heavily damaged during Hazel, as were the homes of ordinary citizens along the coast. At Seventy-sixth Avenue North, the vacation home of Nello Teer was among those reduced from two stories to one. Teer's paving and construction business was responsible for building many of the interstates and highways in the Carolinas. (Courtesy of Barbara Horner.)

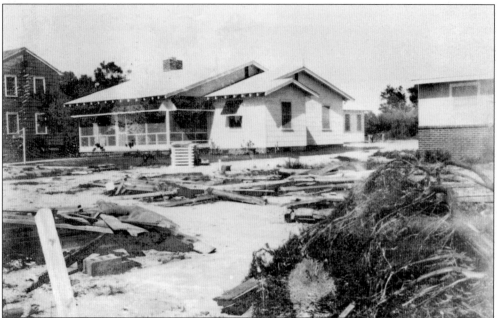

Hazel's storm tides and heavy surf broke apart some homes and knocked others off their foundations. Much of the resulting debris was washed inland by waves, leaving behind windrows of broken timbers, signposts, appliances, and other flotsam. At Seventy-sixth Avenue North, the debris line piled up near the home of W. A. Ward. (Courtesy of Barbara Horner.)

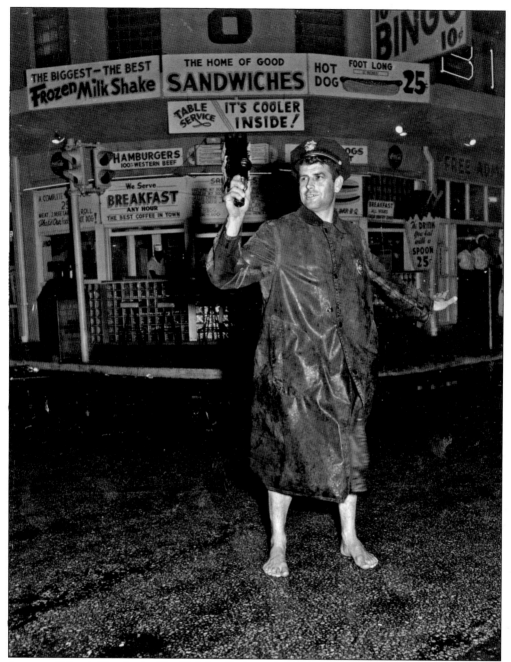

In central Myrtle Beach, the Gay Dolphin Park was largely destroyed, while just two blocks away the famed Pavilion and its amusement park were spared major damage. By the time Hazel made landfall in mid-October, many of the area's seaside attractions had been packed away for the winter, a majority of the town's businesses were closed for the season, and most of the local seaside cottages and resorts were not rented. After the storm, electric lines were downed and stoplights did not work, forcing Myrtle Beach police officers to direct traffic by flashlight. (Courtesy of the *News and Observer*.)

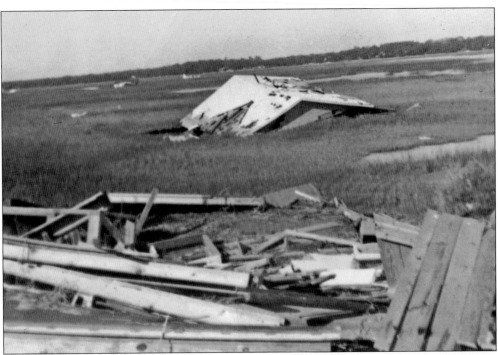

In the days following Hazel, damage assessments were conducted to record the losses along the South Carolina coast. At first, this effort was focused on the popular resort communities near the point of landfall, from Myrtle Beach northward. But among the hardest hit areas was Garden City, South Carolina, just below Myrtle Beach, where an estimated storm surge of 14 feet swept onto the shore. Of the community's 275 homes, only three were livable after Hazel's visit. After the storm, residents were astounded to find some homes completely missing—they counted 42 houses that were washed off their foundations and swept into the marsh between the inlet and the beach. (Above, courtesy of Mr. and Mrs. John F. Davis; below, courtesy of Merlin Bellamy.)

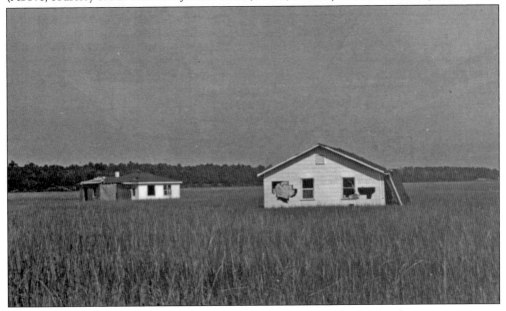

In the days and weeks following the hurricane, local residents along the South Carolina beaches began to recover from the shock of the storm and started to clean up and rebuild. One of the first tasks was to clear roadways of wayward houses and layers of deep sand. After that, restoring electricity wherever possible became a priority. In this photograph, a worker in Garden City inspects an electrical service on a leaning power pole. (Courtesy of Mr. and Mrs. John F. Davis.)

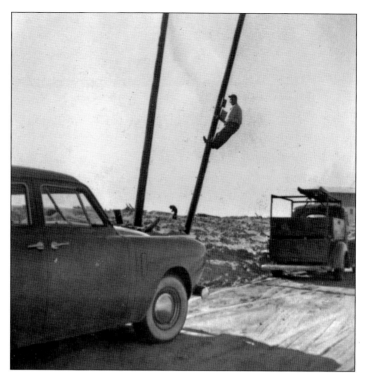

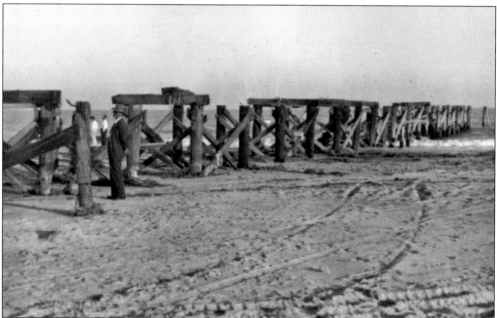

Business leaders in the Myrtle Beach area were effective in generating explosive growth during the 1950s. Just two days prior to Hazel, the *Myrtle Beach News* had editorialized about promoting the term "Miracle Miles" to describe the fun-filled resorts and entertainment offered. After Hazel, a new campaign was launched to lure vacationers back. Landmarks like the heavily damaged Second Avenue Pier would need to be rebuilt to insure that visitors returned. (Courtesy of Mr. and Mrs. John F. Davis.)

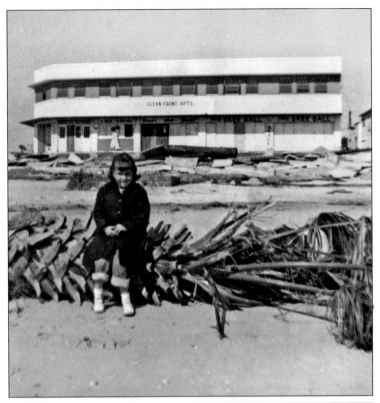

Over a period of weeks through late fall 1954, property owners in Myrtle Beach (many of whom lived in upstate North and South Carolina) returned to the shore to inspect their properties in the aftermath of Hazel. Often they brought their families with them as they inspected their heavily damaged cottages near the beach. What they found was shocking. Some did not have insurance to cover their losses. Salvaging what they could, they began the immense task of rebuilding their ravaged vacation getaways and replacing missing furniture and appliances. But carpenters and roofers were in short supply, and many homes were not repaired quickly. (Above and below, courtesy of Mr. and Mrs. John F. Davis.)

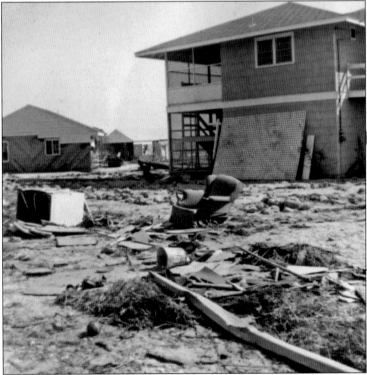

For many people who were present to inspect the beachfront destruction in Myrtle Beach, Cherry Grove, and Ocean Drive after Hazel, the sights drew comparisons with the bombed-out villages they had seen in Europe during World War II. Some homes were lifted by the tides and tossed about, while others seemed to have been pulverized into large jagged piles of wood and concrete. Some roadways were covered by as much as 5 feet of sand. Large trucks and heavy equipment were needed to haul away much of the debris. Like after many other hurricanes, burning the debris was a simple option, and massive bonfires were staged through the winter of 1954–1955. (Above and below, courtesy Mr. and Mrs. John F. Davis.)

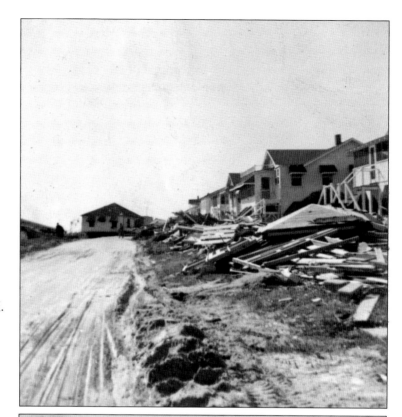

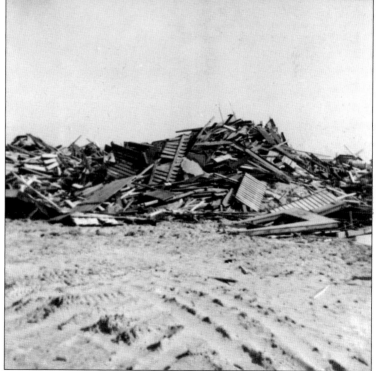

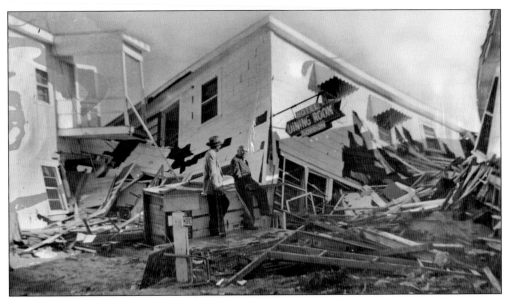

Atlantic Beach, South Carolina, nicknamed the "Black Pearl," is a unique and historic community just north of Myrtle Beach. Settled in the early 1930s by a variety of African American families (many of whom were Gullah and Geechee, generational descendants of slaves from the South Carolina and Georgia coasts), the oceanfront town became a popular vacation destination for black families. African American–owned hotels, restaurants, arcades, and novelty shops thrived along the beach. As with other communities in the region, Hurricane Hazel pounded the oceanfront here too, undermining large structures and washing smaller ones away. Among the heavily damaged buildings here was the Hotel Gordon, along with its adjacent dining hall. (Above and below, courtesy of Alice Graham, Afro-Fest Collection.)

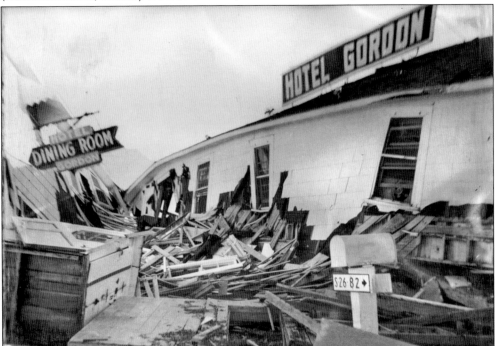

In Crescent Beach, 150 homes were destroyed by Hazel, and 19 had to be removed from rights-of-way. One of the town's oceanfront hotels that received much media coverage after the storm was the Ocean Strand Hotel (right). This popular resort was completely destroyed. Its first floor was flooded and collapsed, tossing the large structure almost on its side. Desks, chairs, and bedding washed into the ocean and the surrounding streets. In nearby Atlantic Beach, the U.S. Coast Guard was called in to dynamite the Lodge Hotel, which suffered a similar fate. Atlantic Beach lost a total of 35 homes. (Right and below, courtesy of Mr. and Mrs. John F. Davis.)

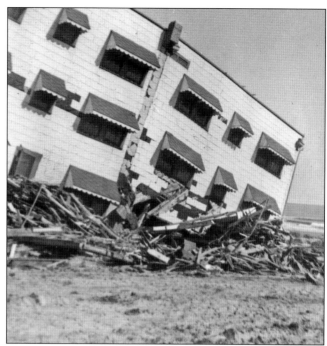

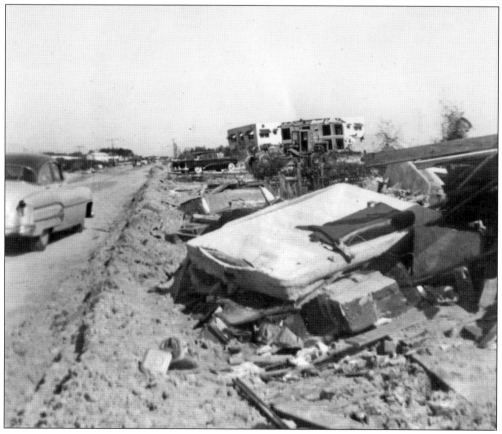

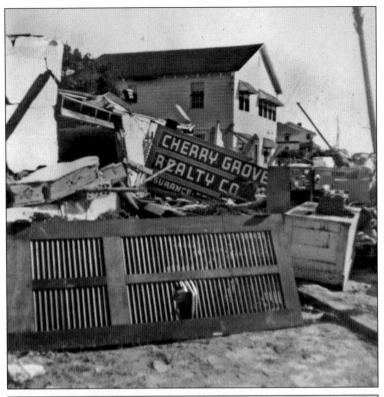

Cherry Grove is the terminus of the Sea Mountain Highway, also known as Highway 9, a popular route for vacationing families traveling to the North Myrtle Beach area during the 1950s. Here Hazel's impact was much like that of its neighboring communities on the South Carolina coast—heavy destruction from storm surge, waves, and ferocious winds. More than 30 homes had to be removed from town streets. The eastern end, known as East Cherry Grove, had no houses remaining after the storm. That portion was completely cut off from the mainland when the roadway over a sandbar that joined the two was washed away and a new inlet was formed. Cherry Grove was also the scene of the state's only fatality during Hazel— Leonard Watts apparently drowned near his cottage. (Above and below, courtesy of Mr. and Mrs. John F. Davis.)

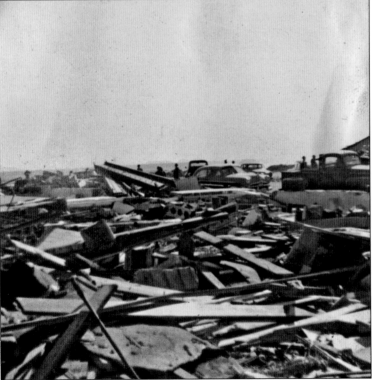

Merlin Bellamy (left) served as police chief of Ocean Drive, South Carolina, for 42 years. He was off duty the night before Hazel arrived, grilling steaks with friends, when he received an urgent telephone call at 10:30 p.m. from a forecaster in Charleston asking if he was prepared for the hurricane. Like everyone else, the chief vaguely knew a storm was supposed to pass offshore, but he had no idea it was about to land in his town. At the forecaster's urging, Bellamy worked through the night, knocking on doors and evacuating residents. Many had no transportation, so he loaded them into his squad car and made repeated trips to a nearby shelter, each time wondering if he would make it back over the bridge to the beach. As a result of his efforts, there were no casualties in Ocean Drive. (Courtesy of Merlin Bellamy.)

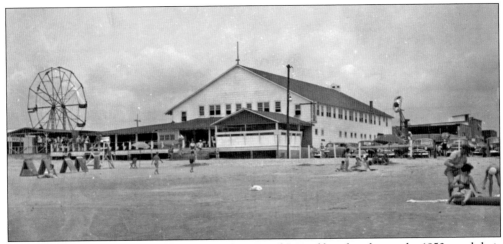

Young people flocked to Ocean Drive and other Grand Strand beaches during the 1950s, and their favorite hangouts were the famous pavilions that become well known for shag dancing. Among the most famous was Robert's Pavilion, built in 1936; it was cut in half by Hazel's storm tide in 1954. Other popular pavilions were also destroyed by the hurricane, including Sonny's Pavilion in Cherry Grove and Spivey's Pavilion in Myrtle Beach, both of which were simply gone after the storm. These before and after photographs of Robert's Pavilion illustrate the destructive energy Hazel delivered. Following Hazel, a new O. D. Pavilion was erected on the former site of the old Robert's, reusing many of the original structure's timbers. (Above, courtesy of Merlin Bellamy; below, courtesy of Mr. and Mrs. John F. Davis.)

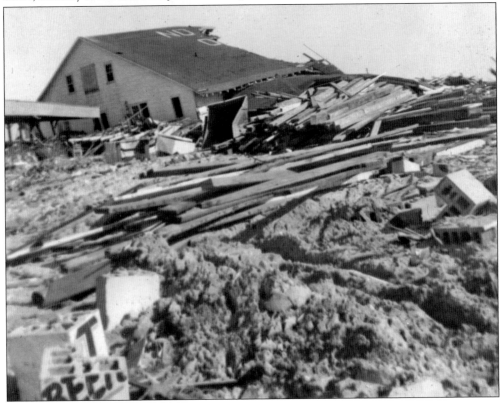

On Ocean Drive and the newly incorporated Tilghman Beach, 450 houses were heavily damaged or destroyed in the hurricane. Though many vacation homes were vacant because the season had ended, some of the lost homes were full-time residences. Typical of the destruction was the Ocean Drive home pictured at right. (Courtesy of Mr. and Mrs. John F. Davis.)

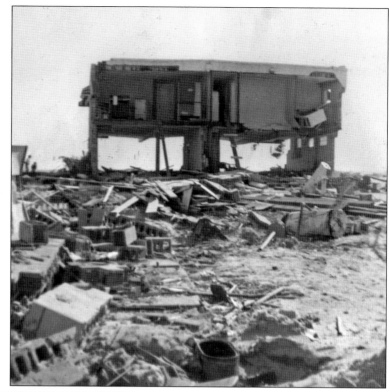

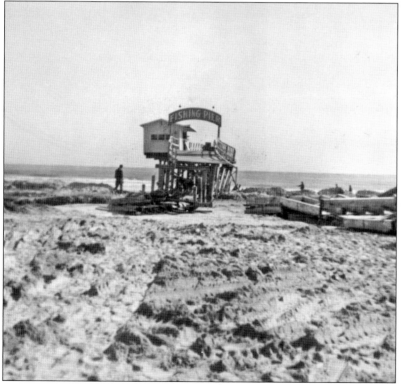

The Tilghman Pier was a popular landmark that was completely destroyed by Hazel's waves. Oddly, after the hurricane passed and the wind switched direction, the ocean receded to an extreme low. Chief Bellamy stated, "The tide was so low that I could have driven around the end of the Tilghman Pier, if it was still there." (Courtesy of Mr. and Mrs. John F. Davis.)

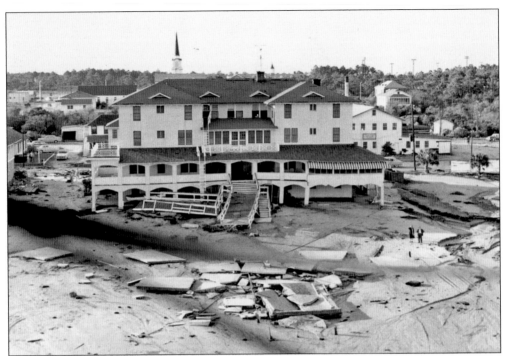

Prior to Hurricane Hazel in 1954, the last major hurricane (Category 3 or higher) to hit the Grand Strand was in 1906, almost 50 years before Hazel made landfall as a Category 4 and went on to become a benchmark hurricane for South Carolina residents. In all, Hazel tallied more than $27 million in losses from Pawley's Island to Cherry Grove (in 1954 dollars). But some say all the destruction in the Myrtle Beach area actually jump-started a new kind of development, paving the way for the high-rise hotels and condominiums that would later be built where cottages once stood. Today's Grand Strand boasts a population exceeding 250,000, far more than the 4,000 or so Myrtle Beach residents who experienced Hurricane Hazel. (Above and below, courtesy of the U.S. Air Force.)

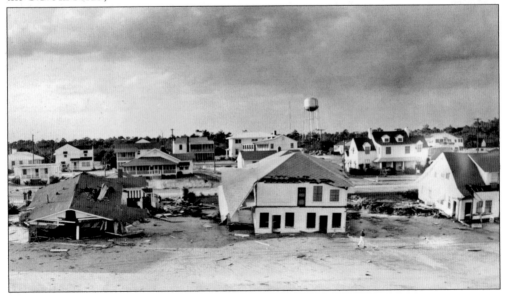

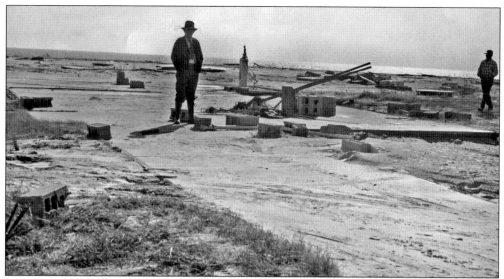

Hazel's landfall near the North Carolina–South Carolina border focused its most extreme storm tides on all the beaches nearby. But it was the North Carolina beaches, hit by the more powerful right-front quadrant of the hurricane that experienced the highest storm surge and the greatest destruction. The surge measured 18 feet above mean low water at Calabash, 17 feet at Long Beach (Oak Island), and 13 to 15 feet at Carolina and Wrightsville Beaches. (Photograph by Art Newton; courtesy of Punk Spencer.)

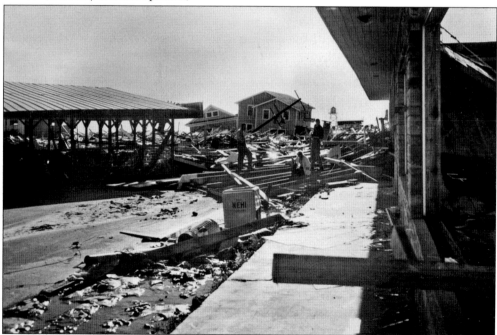

Ocean Isle Beach was one of several Brunswick County, North Carolina, beaches to be covered by surging storm tides during Hazel. Nine lives were lost at Ocean Isle. The Weather Bureau office in Raleigh, North Carolina, reported, "All traces of civilization on the immediate waterfront between the state line and Cape Fear were practically annihilated." In this photograph, unidentified visitors inspect the damage at the Ocean Isle Amusement Center. (Courtesy of the Cape Fear Museum.)

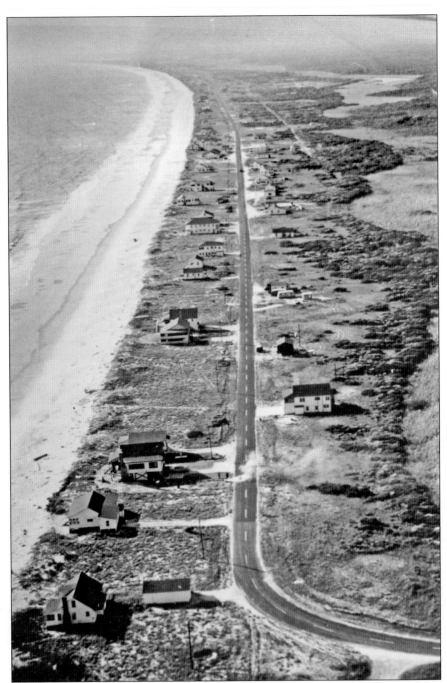

Long Beach, now known as Oak Island, is a popular family beach near Southport. This photograph, taken at Long Beach prior to Hurricane Hazel, shows many of the island's 357 cottages. After the storm, 352 were found swept from their foundations and washed into the marsh thickets behind the beach. Fortunately, most of the houses were empty at the time. And unlike today's typical beach home, in 1954 none were elevated on pilings—they were built directly on concrete slabs. Residents who returned to the island after the storm were disoriented because all the beach's landmarks had been swept away. (Courtesy of the U.S. Army Corps of Engineers.)

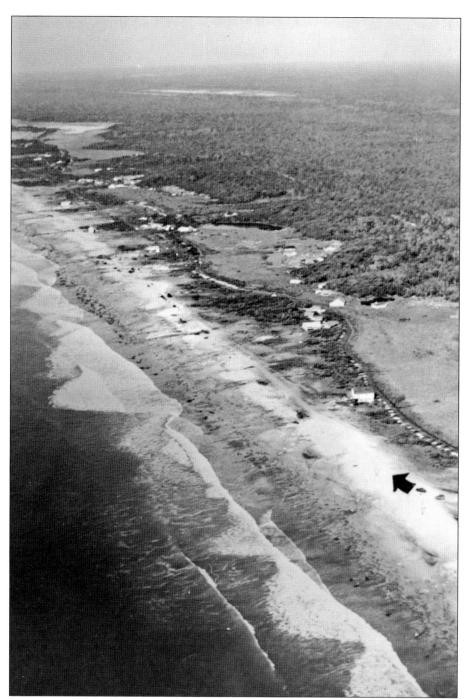

This photograph, taken just after Hazel, shows the storm surge's effect on the same stretch of Long Beach as in the photograph on the previous page. The arrow indicates where the bend in the road once was. On a flight down the coast, it was easy to see that homes were destroyed, the roadway was gone, and the island's 15-to-20-foot-high natural dunes were flattened. Because the beach was so clean and flat, small airplanes landed there in the weeks after the storm. (Courtesy of the U.S. Army Corps of Engineers.)

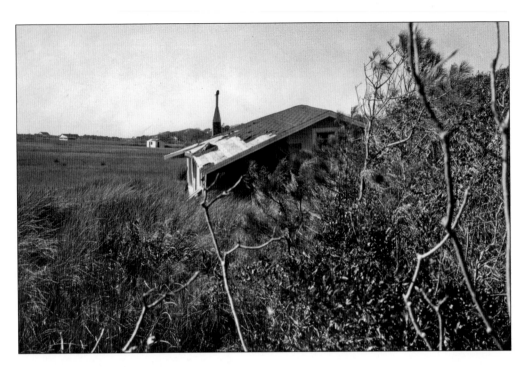

Connie and Jerry Helms were some of the only people on Long Beach the night that Hazel arrived, as they were there on their honeymoon and did not know about its approach. When the storm tide reached their cottage, they were forced to escape to a nearby two-story structure and ultimately had to float out a second-floor window on a mattress. Both homes floated across the island and into the marsh, as did the couple on the mattress. Jerry eventually held on to a tree branch until the tide receded, then the two walked for miles back to the main highway. Their survival story was retold 50 years later on the Weather Channel's television show *Storm Stories*. (Above and below, photographs by Art Newton; courtesy of Punk Spencer.)

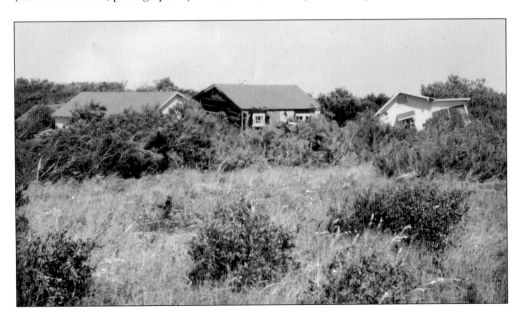

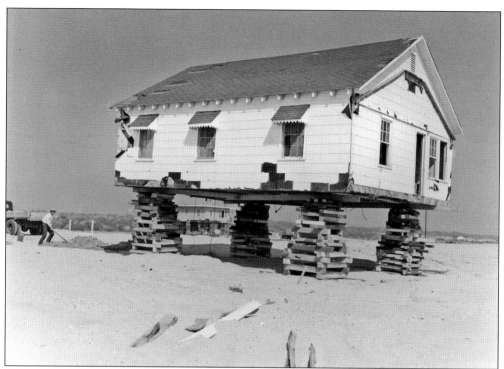

On Long Beach, several of the homes swept into the marsh were later retrieved. Crews worked to haul them back onto the beach, where they were repositioned and rebuilt. Many were later elevated onto pilings to better withstand future inundations. Appliances, gas tanks, and even cars were also pulled out of the marsh. Another rebuilding effort on the Brunswick beaches was the recreation of miles of lost sand dunes. By early 1955, a line of modest dunes had been constructed on Long Beach, Holden Beach, Ocean Isle Beach, and Sunset Beach. The new dune can be seen in the background of the photograph below. (Above and below, courtesy of Hugh Morton.)

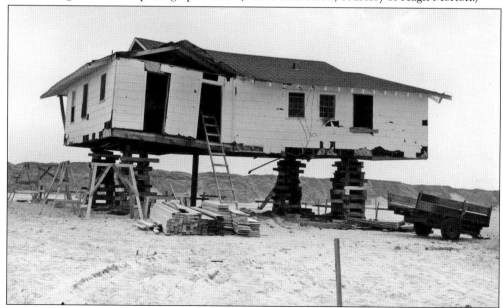

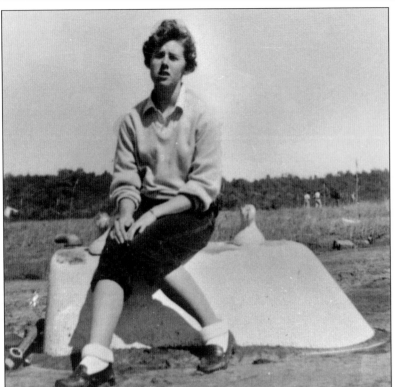

In the days following Hazel, property owners and the curious traveled out to Long Beach to witness the destruction left behind. For most, there was a sense of bewilderment when they arrived because so few landmarks existed and there was little to see. Scattered along the beach were only appliances and fixtures, like the tub discovered by this unidentified girl. (Courtesy of Lewis Hardee.)

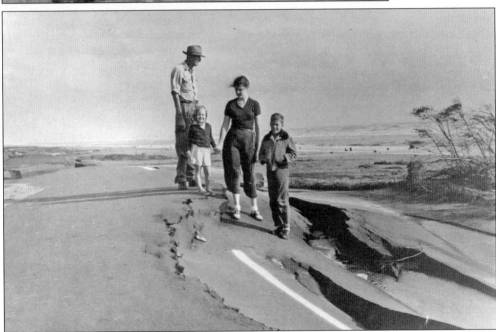

Roads along the beach that were not covered in deep sand were undermined and broken. Large sections of Caswell Beach Road were washed away, briefly isolating facilities on the eastern end of Oak Island. For decades afterward, large chunks of broken asphalt could be found in the dunes and near the water on Caswell Beach. (Courtesy of the author.)

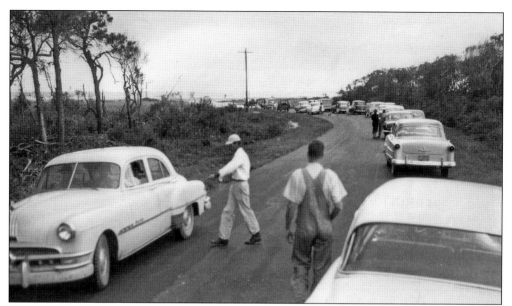

Cars lined up on the beach road to try to get onto Yaupon and Long Beach following Hurricane Hazel. (These communities merged in recent years to form the town of Oak Island.) Transportation onto the island was not easy, except for the light airplanes that were able to land on the smooth, flat, sandy beach that was left after the storm. (Photograph by Art Newton; courtesy of Punk Spencer.)

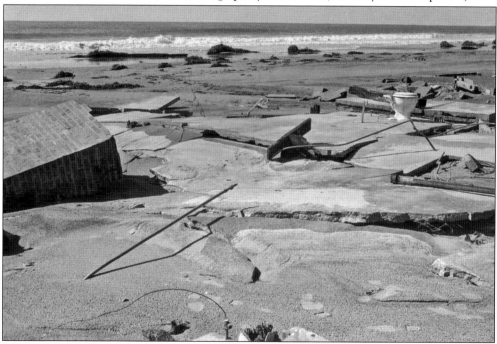

Artist and photographer Art Newton captured some of the best images of Hazel's impact on the Southport and Long Beach area. Many were used by the *State Port Pilot* in Southport and in a special publication, *Hurricane Hazel Lashes Coastal Carolinas*, printed by the Wilmington Publishing Company. In this photograph, Newton captured a familiar scene from Long Beach. (Photograph by Art Newton; courtesy of Punk Spencer.)

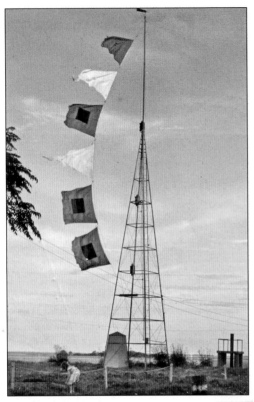

Southport, a historic town at the mouth of the Cape Fear River in Brunswick County, was built around the Fort Johnson garrison that sits on a high bluff above the river. Prior to the arrival of a hurricane, signal flags were raised on the garrison's tower to warn passing ships and local residents about the approaching threat (pictured at left). After Hurricane Hazel, the flags were missing and tattered (below). Though it did not face the ocean directly, Southport still caught the brunt of the hurricane and suffered significant damages from sunken and scattered boats, flooded homes, and toppled trees and power lines. (Left and below, photographs by Art Newton; courtesy of Punk Spencer.)

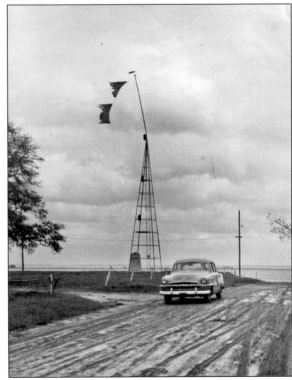

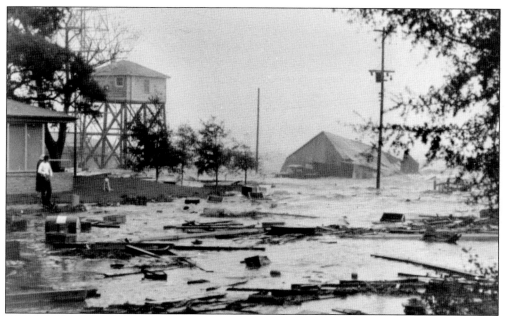

Along the Southport waterfront, Hazel's storm surge was estimated at 6 to 8 feet. River-facing docks and shrimp houses suffered heavy losses in the storm. Among the buildings destroyed was Harrelson's Grocery, though owner Dan Harrelson was able to salvage a small portion of his store's inventory just before rising water filled the aisles. From the top of the town's pilot tower, Art Newton snapped the view below of the waterfront looking down West Bay Street as the river rose into the streets. The yacht basin and most of Caswell Avenue were already underwater in this photograph, but ultimately all of West Bay Street was covered by the tide. (Above, photograph by Art Newton, courtesy of the *State Port Pilot*; below, photograph by Art Newton, courtesy of Punk Spencer.)

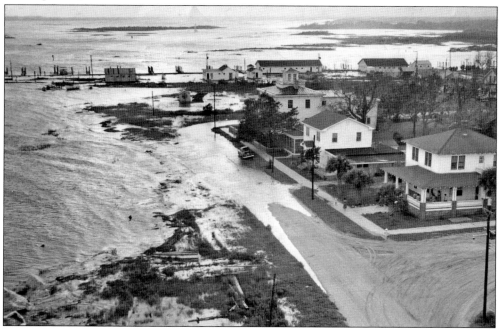

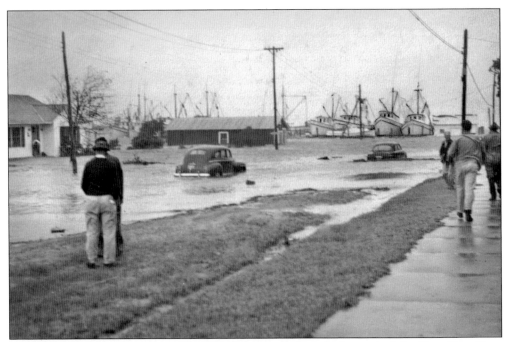

As Hazel's powerful central core spun toward land, winds and tides pushed the Cape Fear River into the streets of Southport. Local residents approached the yacht basin on the morning of the storm to see waters already covering West Moore Street (above). Within hours, the surge reached its peak, floating huge 45-ton shrimp trawlers up and over their docks and into the streets. Some of the vessels drifted into town, crashing into homes and knocking over power poles. After the hurricane passed, a variety of wreckage was visible around the yacht basin, including broken sections of dock, washed-out cars, and displaced boats (below). (Above, photograph by Art Newton, courtesy of Punk Spencer; below, photograph by Art Newton, courtesy of the *State Port Pilot*.)

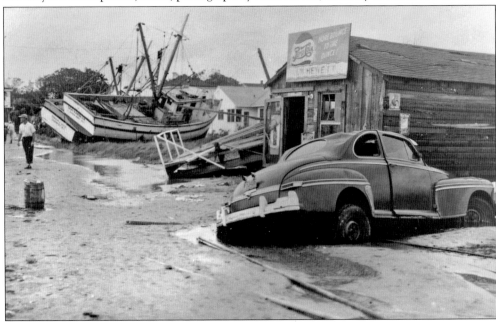

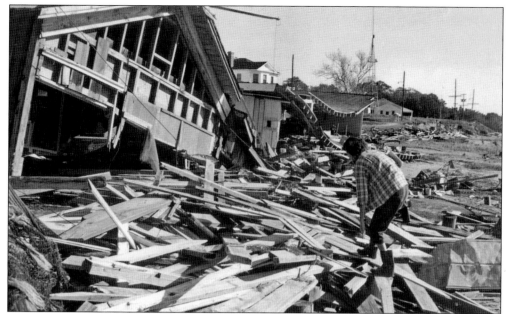

The Southport waterfront was covered with mounds of broken timber in the aftermath of Hazel. Bay Street's docks and shrimp houses were all destroyed, along with the riverfront Harrelson's Grocery. In the years following Hazel, most of the docks on the river were never rebuilt. The portion of the waterfront near the foot of Howe Street was a central meeting point for people who came down to inspect the damage (above). Though winds probably topped 140 miles per hour, Southport's pilot tower (background, below) was not noticeably affected. (Above, photograph by Art Newton, courtesy of Punk Spencer; below, photograph by Art Newton, courtesy of the *State Port Pilot*.)

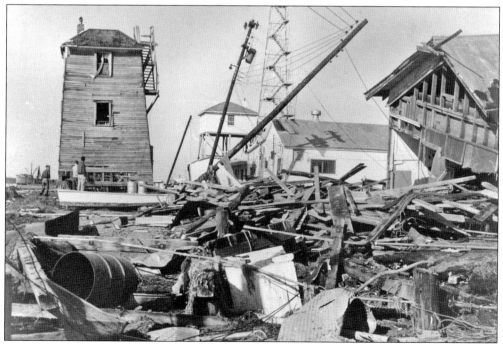

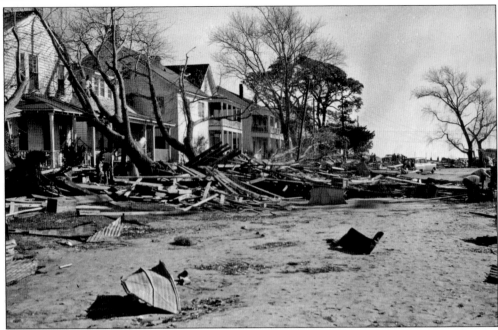

Looking east down Bay Street (above), Southport's riverfront was a scene of destruction following Hurricane Hazel. Large hardwood trees were tossed onto homes, and rafts of broken docks and buildings were stacked high in people's yards. At the peak of the storm, water entered the first floor of several of the homes nearest the river. Still standing but partially damaged, the Riverside Motel (below, right) survived the hurricane under the shadow of the pilot tower and is still in operation today. Though Bay Street had seen flooding during the 1944 hurricane and other storms, Hazel delivered the highest tides in memory. (Above, photograph by Art Newton, courtesy of Punk Spencer; below, courtesy of the Cape Fear Museum.)

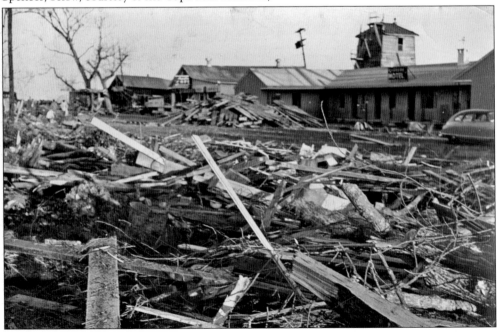

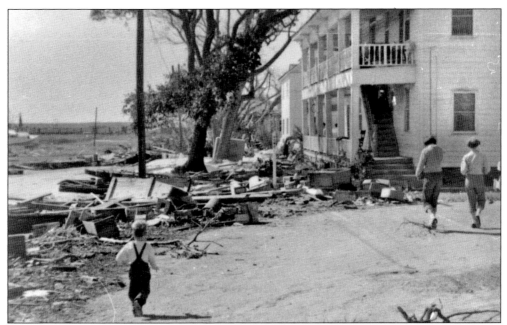

Like other communities affected by Hurricane Hazel, the people of Southport were hurt economically by the storm. In addition to the damaged homes, most of the town's waterfront fish houses were destroyed. Fishing was the lifeblood for many residents, and the loss of the fishing fleet, the docks, and the infrastructure to support them was significant. Once the docks and buildings were busted apart by high water and waves, their pilings and deck boards washed into neighborhoods and filled streets, as seen at the south end of Lord Street (below). The following day, shrimp dock owner Lewis Hardee said he crawled through the wreckage with a carpenter's crayon, marking his name on each board of costly cypress that he believed was his. (Above, photograph by Art Newton, courtesy of the *State Port Pilot*; below, photograph by Art Newton, courtesy of Punk Spencer.)

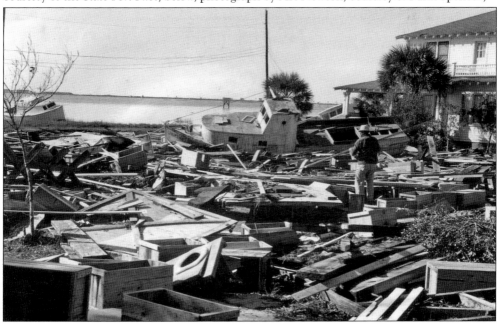

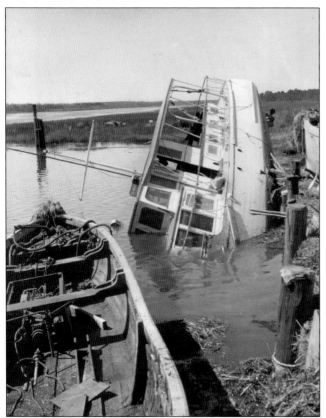

In addition to the larger trawlers, many of the other fishing boats in the Southport yacht basin were tossed up on land or sunk in their berths. Though the U.S. Coast Guard had issued warnings about high waters expected with the hurricane on the day before Hazel struck, no one could have predicted the record surge that swept over the wharves and pushed boats around like toys. Some boat captains had prepared their vessels the best they could, while others just did not get down to the waterfront in time to relocate their boats to safe harbor. One fishing boat (below) was lashed so well to its dock that when it broke free it took a section of the dock with it, fuel pump and all. (Left and below, photographs by Art Newton; courtesy of Punk Spencer.)

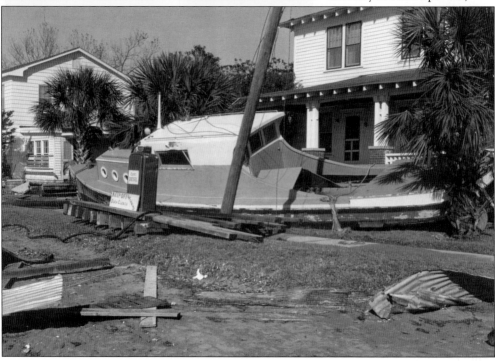

The *State Port Pilot* has been reporting the news in Southport since it was founded in 1928, and Hurricane Hazel in 1954 was one of its biggest stories. News of the storm was of particular interest to people throughout the Piedmont who owned vacation homes on Long Beach, Yaupon Beach, and Caswell Beach. (Courtesy of the *State Port Pilot*.)

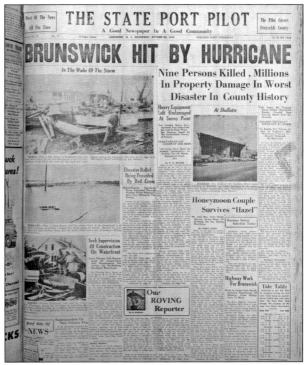

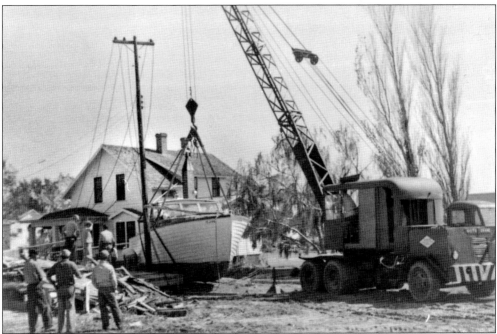

After Hazel moved northward, Southport residents surveyed the damage and began cleaning up their streets of timber and other debris. But moving larger items, like wayward fishing boats, presented a greater challenge, so cranes from the nearby U.S. Army ammunition depot at Sunny Point were brought in to assist. Many of the boat captains were able to make minor repairs and return to fishing soon after the storm. (Courtesy of Leila Pigott.)

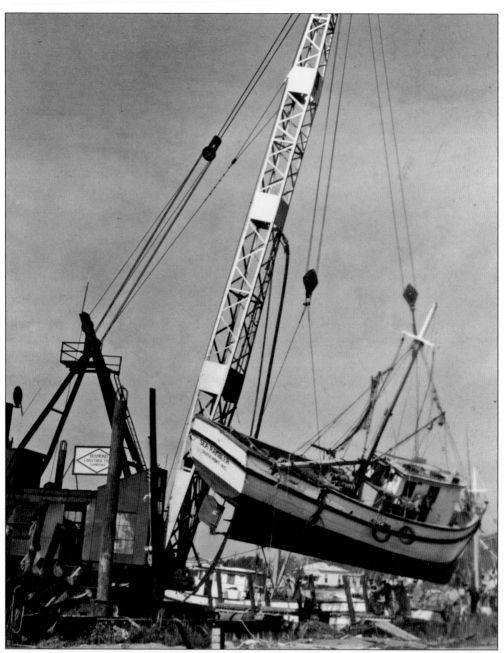

Over several days, cranes from Sunny Point helped relocate fishing boats and shrimp trawlers, like the *Sea Rambler*, placing them back in the water after their brief adventures on land. Years later, one Southport resident told the story about her husband, skipper of one of the trawlers, who left the morning of the hurricane to go and secure his boat. As the hurricane reached its peak and floodwaters encircled her home, she watched as a large trawler drifted down the street toward her. She thought her husband was onboard. But the trawler was actually unmanned, and it proceeded to smash into her dining room before coming to a stop. (Courtesy of the *State Port Pilot*.)

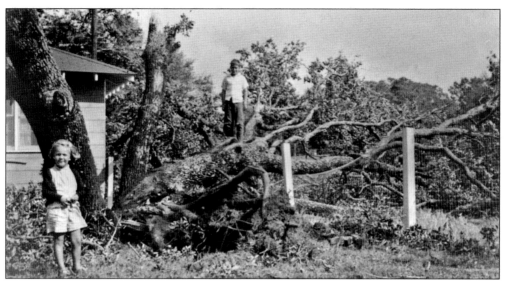

Southport, long known for its ancient and majestic live oaks, was rocked by Hazel's 130-plus-mile-per-hour winds. Many of the oaks split under the force of the gusts, sometimes crushing cars or homes beneath them. On Atlantic Avenue, this oak fell next to the home of the author's parents, to the amazement of the author's sister, Sarah Barnes Whittington, age three (left). (Courtesy of the author.)

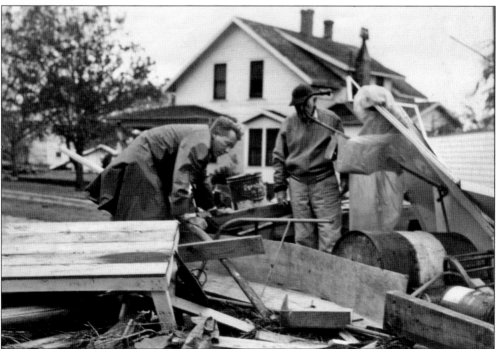

It took weeks for the streets of Southport to be cleared of the maze of storm-tossed debris following Hazel. Residents salvaged what pieces they could and sometimes reclaimed missing items, but they also hauled damaged furnishings to the street for pickup. Most residents then repaired their homes as best they could and prepared for the arrival of cooler weather. (Photograph by Art Newton; courtesy of Punk Spencer.)

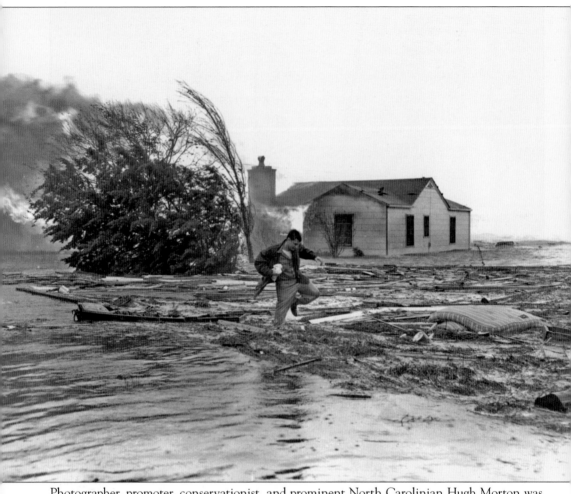

Photographer, promoter, conservationist, and prominent North Carolinian Hugh Morton was in Carolina Beach when Hazel raced ashore on the morning of October 15, 1954. He snapped this photograph of friend and fellow photojournalist Julian Scheer wading through a debris-strewn portion of the flooded town. Behind Scheer, a house burns without much chance of firefighters saving it. Morton's photograph won first prize for spot news from the North Carolina Press Photographer's Association for 1954. Scheer was in Carolina Beach on assignment from the *Charlotte Observer*, and a few of his photographs from Hazel were published in *Life* magazine. He went on to become the public affairs director for NASA (National Aeronautics and Space Administration) during the Apollo moon missions of the 1960s. (Courtesy of Hugh Morton.)

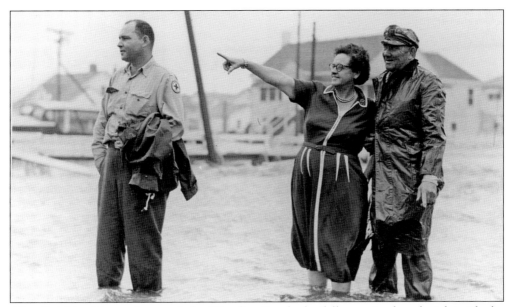

Alice Strickland (center), town clerk of Carolina Beach, dutifully remained on the job inside the small town hall during Hurricane Hazel. As the storm passed through and the waters began to recede, she ventured into the streets to direct a Red Cross official as waters swirled around her knees. None of the coastal communities affected by Hazel had the equipment or personnel on hand to cope with the magnitude of the disaster. (Courtesy of Hugh Morton.)

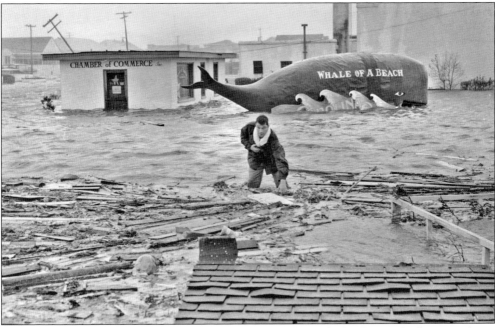

Hugh Morton's photograph of Julian Scheer in front of the "Whale of a Beach" float is a classic Hazel image and is often featured on the UNC Chapel Hill Library's "A View to Hugh" blog. When the town of Carolina Beach created the float for the Wilmington Azalea Festival parade in April 1954, it was so popular that it was later parked in front of the chamber of commerce building to greet vacationers. (Courtesy of Hugh Morton.)

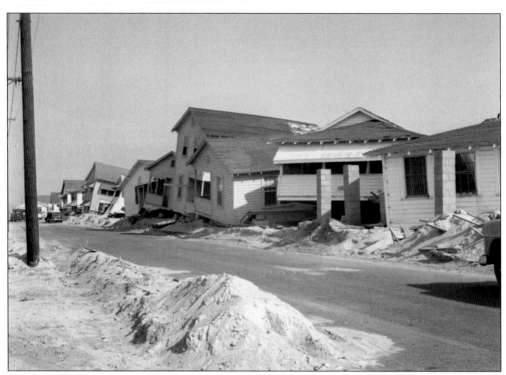

Hazel tracked inland over the lower portions of Brunswick County and pushed inland toward Raleigh. New Hanover County, North Carolina, including its popular beach towns, took a direct hit from the storm's powerful right side. Carolina Beach and Wrightsville Beach were especially prone to destruction from storm surge. Pounding waves and high water pushed through the streets of Carolina Beach, knocking scores of houses off their foundations and leaving them tossed at crazy angles. Many were later righted and restored, while others were demolished. (Above, courtesy of the North Carolina State Archives; below, courtesy of Suzanne Paradis.)

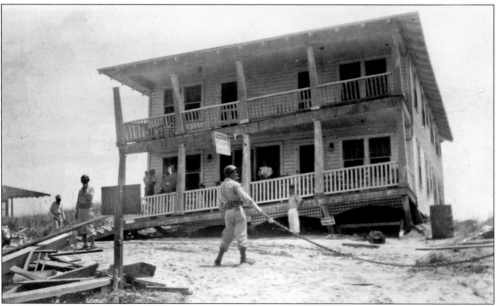

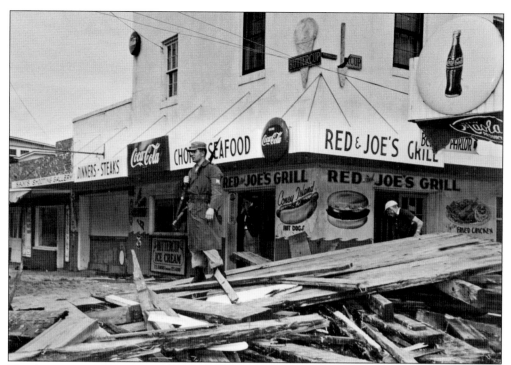

The downtown portion of Carolina Beach was hit hard by Hazel's winds and tides. Large mounds of timber from the oceanfront boardwalk area blocked streets after the storm. Deep layers of sand were also a problem, washed in from the beach and spread across town for several blocks. Like many coastal towns pounded by Hazel, city officials in Carolina Beach feared looters would arrive and help themselves to homes and stores opened up by the hurricane. National Guard units were called in to stand watch over the business district until owners could secure the properties. These National Guard units also were assigned the task of searching for potential victims of the storm. (Above and below, courtesy of the Cape Fear Museum.)

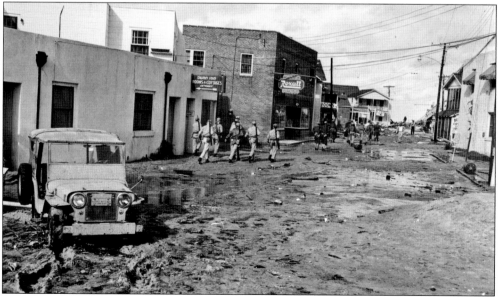

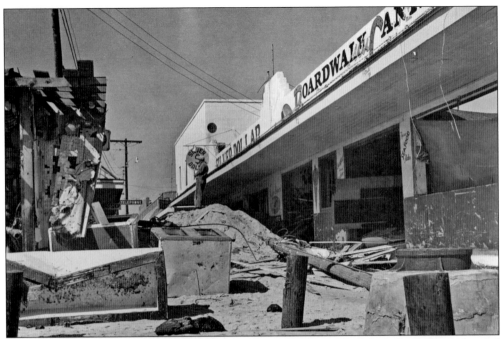

The narrow alleyways, arcades, and pool halls within the Carolina Beach boardwalk district bustled with young people during the crowded summer season of 1954. The boardwalk's popularity during summer was at the heart of the Carolina Beach economy, as many residents in town depended on the boardwalk as a perennial tourist draw. Fortunately it was empty when Hazel came calling in mid-October. But the hurricane was not kind to the boardwalk itself, or the many soda shops and other businesses that comprised the downtown. Monstrous waves rolled through the streets, busting glass windows and flooding every shop in the area. The Silver Dollar arcade (above) was one of many structures gutted by Hazel's storm surge. (Above and below, courtesy of the Cape Fear Museum.)

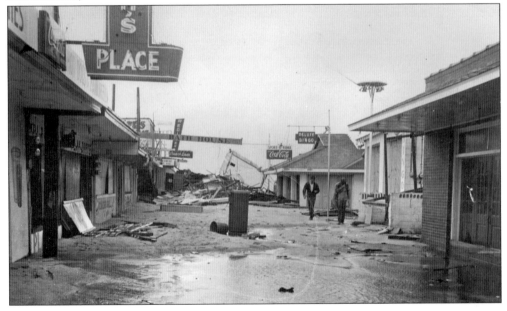

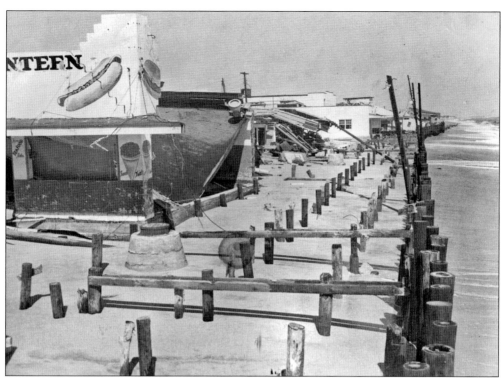

The Carolina Beach boardwalk (above) was disassembled by the rising tides of Hurricane Hazel. Most of the timbers that once made up the walkway were washed blocks inland and later found stacked in large piles. Virtually every oceanfront business in the boardwalk district was heavily damaged. Many structures were not only flooded, but also lost their roofs and even walls to winds that exceeded 100 miles per hour. Though most business owners had already closed down and boarded up for the winter season, the locked doors and plywood-covered windows were no match for Hazel's fury. (Above and below, courtesy of the Cape Fear Museum.)

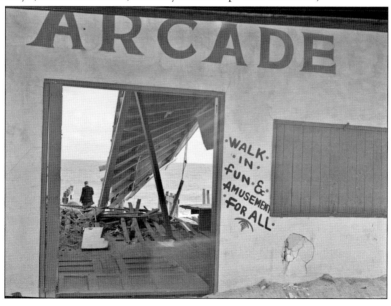

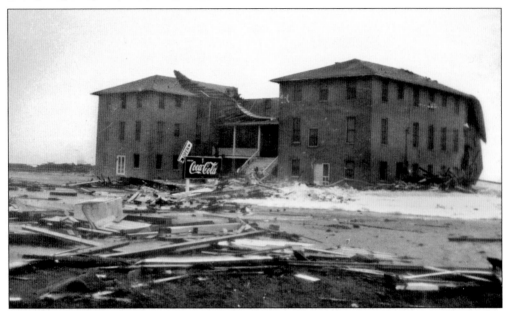

The Breakers Hotel in Wilmington Beach (now part of Carolina Beach) was just one of the properties heavily damaged by Hazel's lashing of the coast. Although no official measurements were made of the storm surge in Carolina Beach, estimates ranged between 13 and 15 feet above mean low water. Hazel's surge effect was made worse by the unfortunate timing of its arrival—during a full moon high tide, which during October is one of the highest astronomical tides of the year. This lunar effect likely added at least 2 feet onto the elevation of the hurricane's normal storm surge. (Above, courtesy of the Cape Fear Museum; below, courtesy of the North Carolina State Archives.)

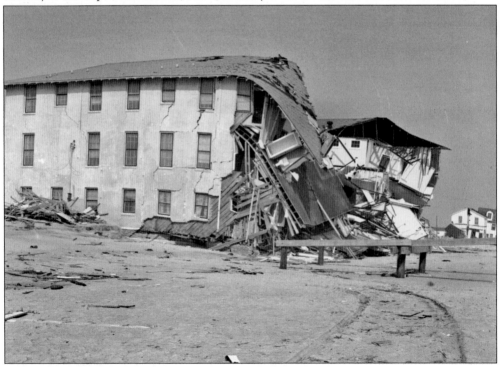

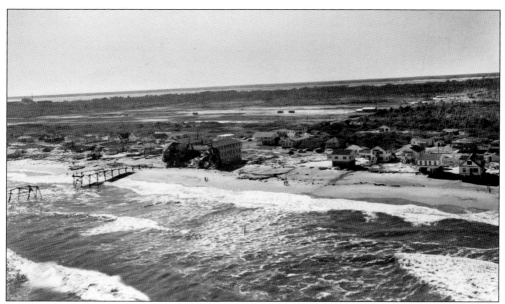

An aerial view of Wilmington Beach and the Breakers Hotel (above) shows the damage to the first-row structures and to the hotel's fishing pier. Waves from Hurricane Hazel broke the pier into sections. Grand plans for the development of Wilmington Beach were first launched in 1913 with a proposal for large hotels, several fishing piers, a pavilion, and other amenities. When the three-story, 50-room Breakers Hotel finally opened in 1924, it was New Hanover County's first oceanfront brick hotel. But it was no match for Hazel's surge, which caused extensive damage. The building was later demolished. Bricks from the Breakers were later used to stabilize the shoreline at Fort Fisher. Wilmington Beach was eventually annexed by the town of Carolina Beach. (Above, courtesy of the Cape Fear Museum; below, courtesy of the North Carolina State Archives.)

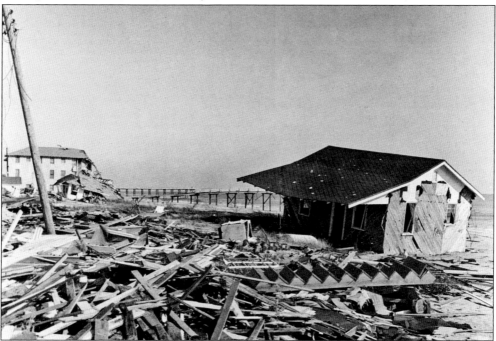

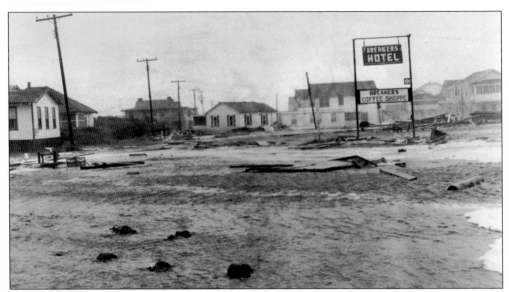

In Wilmington Beach, a deep layer of sand covered the beach highway on Pleasure Island just hours after Hazel's passing. A distant house (center) can be seen in the road, repositioned after floating from its oceanfront foundation. The Breakers Hotel and Coffee Shop sign remained standing, having somehow endured the 100-plus-mile-per-hour winds that whipped the resort community during the storm. (Courtesy of the Cape Fear Museum.)

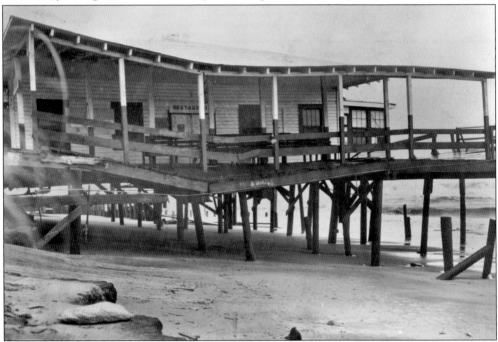

Among the structures demolished by Hazel was the Fort Fisher Fishing Pier, seen here just days after the storm. Built in 1936 by Walter Winner, the pier was popular in the 1940s when fishing cost just 35¢ per day. It was constructed just a half-mile north of the fort over top of the shipwrecked remains of the Civil War blockade-runner *Modern Greece*. It was one of many piers knocked down by the hurricane. (Courtesy of the Cape Fear Museum.)

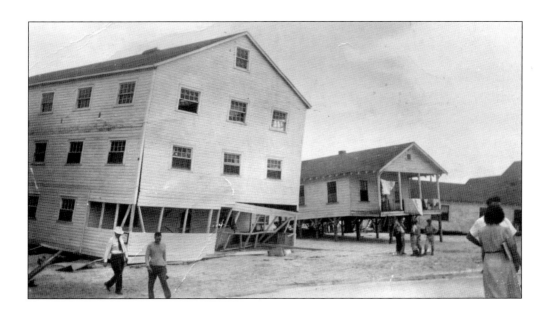

No other single community on the Carolina coast suffered more total property damage during Hazel than did Carolina Beach. The popular resort was more developed than the Brunswick beaches, and newspaper reports stated that 14 blocks of the town were underwater during the storm. In all, 362 buildings were completely destroyed here, and another 288 suffered major damage, for a total estimated loss of $17 million (in 1954 dollars). And with little advanced warning, not all residents evacuated for the storm. Some who stayed told stories of climbing onto their kitchen cabinets to avoid the swirling waters that entered their homes. Emergency workers used the town hall as a headquarters until rising waters forced them to pack their equipment and documents and move to higher ground in the China Café. (Above and below, courtesy of Suzanne Paradis.)

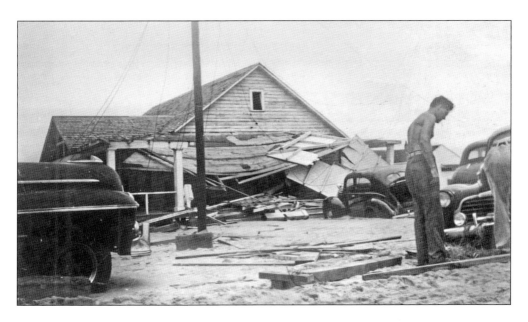

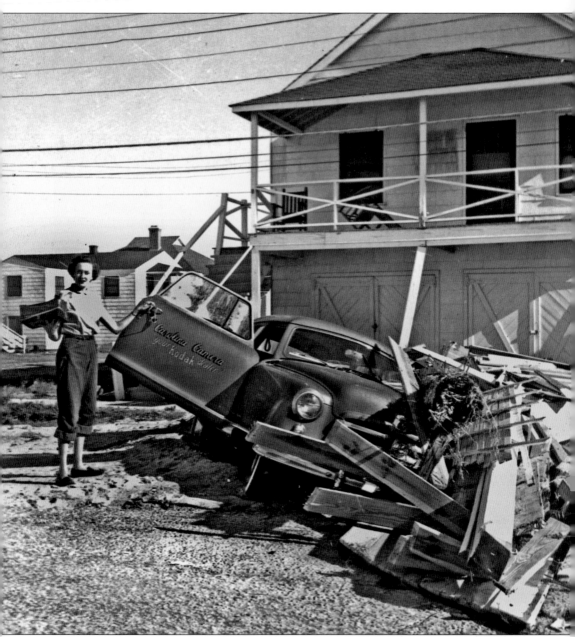

In 1954, Wrightsville Beach was one of the premier resort beaches on the Carolina coast, just as it is today. With rows of oceanfront homes owned by prominent families from across the state and a bustling downtown business district, Wrightsville had much to lose in a major hurricane. Hazel hit the city hard. Winds blasted the taller, larger vacation homes that were common throughout town. Then a 12- to 14-foot storm surge pushed through the dunes and into the streets, flooding businesses and knocking down large oceanfront structures. In this photograph, an unidentified woman in Wrightsville retrieves items from a car marked "Carolina Camera—Your Kodak Dealer." (Courtesy of the Cape Fear Museum.)

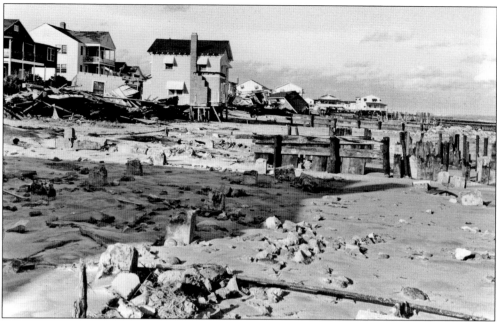

Wrightsville Beach had experienced devastating hurricanes prior to Hazel, most notably storms in September 1856 and on Halloween day in 1899. Like Hazel, these were both full moon hurricanes that delivered a large storm surge. But the surge from Hazel was much more destructive due to the greater number of homes and businesses on the island in 1954. Many of the beachfront homes on the front row just vanished. In the Hugh Morton photograph above, the battered cottages that remained on this stretch of the beach were once second row, but now the first row is missing. (Above, courtesy of Hugh Morton; below, courtesy of the *News and Observer*.)

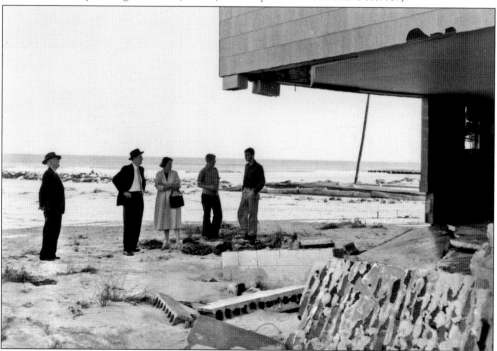

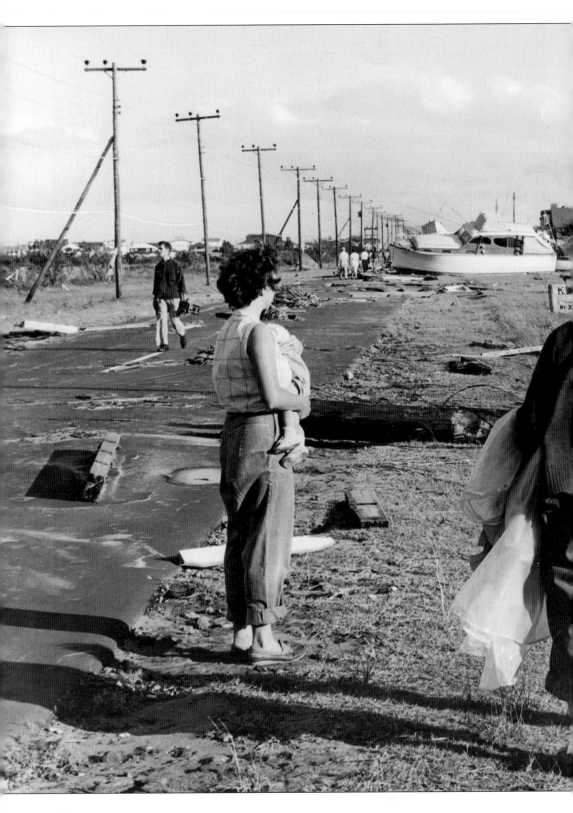

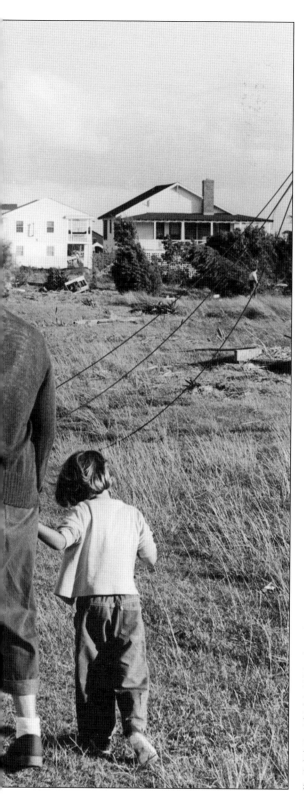

The summer and fall of 1954 produced several runs of record heat across the eastern United States. In North Carolina, an all-time September high temperature was recorded in Weldon (109 degrees Fahrenheit), followed by an all-time October record set in Albemarle (102 degrees Fahrenheit). It is not known whether or not the warmer temperatures through that period might have contributed to Hazel's fury by raising ocean temperatures just off the coast. But it is known that just days after the hurricane crossed through the Carolinas, seasonably cooler temperatures moved into the area. As home and boat owners arrived to inspect their properties, many brought sweaters and jackets. (Courtesy of Hugh Morton.)

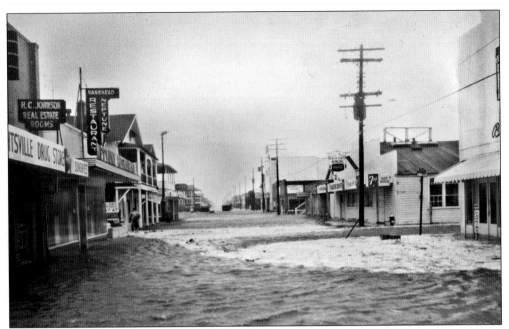

After Hurricane Hazel made landfall, it passed some 40 miles to the west of Wilmington on its way toward Raleigh and several northern states. At Wrightsville Beach, its storm surge was amplified by the full moon and pushed high over the frontal dunes through dozens of homes. Floodwaters filled Lumina Avenue (above), drowning out many of the city's beach shops, restaurants, grocery stores, and other businesses. The King Neptune Restaurant (below), an institution at Wrightsville since 1946, was flooded with nearly waist-deep water during the storm. The restaurant rebuilt and is still in operation today. (Above and below, courtesy of the Cape Fear Museum.)

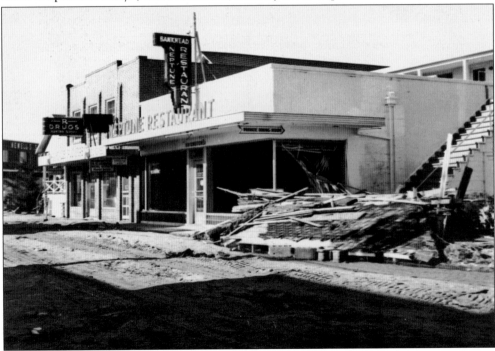

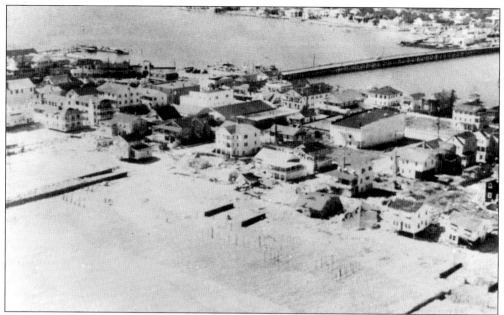

An aerial view of the Station One section of Wrightsville Beach, photographed after Hazel, reveals the dramatic loss of the front-row cottages through that stretch of beach. In this photograph, the Birmingham Street jetty is on the left, the Atlanta Street jetty is on the right, and Harbor Island is in the background. (Courtesy of Bill Creasy.)

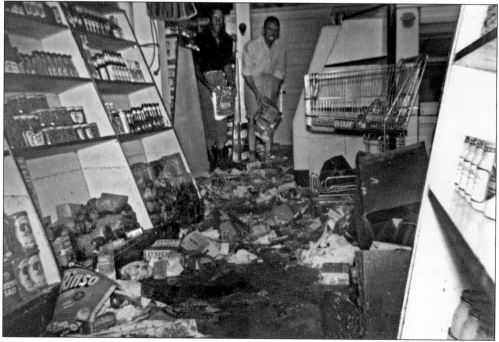

Foamy saltwater swept into the heart of Wrightsville, soaking street-level businesses up and down Lumina Avenue. Among those who lost much of their inventory was Roberts Grocery. Floodwaters washed products off their shelves and damaged equipment in the store. In this photograph, a high water line can be seen on the sloped white cabinets on the left. (Courtesy of the Cape Fear Museum.)

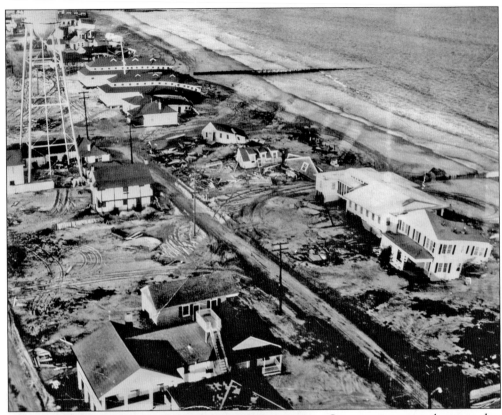

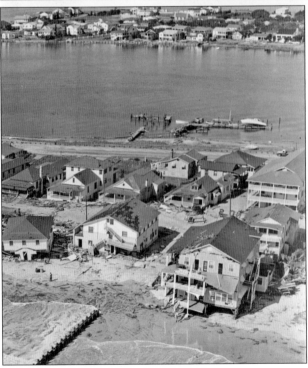

One way many people across the country learned about Hazel's impact in the Carolinas was from an audio report by WPTF radio's Carl Goerch. Goerch provided narration as he toured the oceanfront destruction on the Cape Fear coast in a low-flying DC-3 airplane. From the air, the broader scope and magnitude of the disaster was evident. Damages to the Wrightsville Beach police station (above, left) and other buildings near the water tower are visible in this aerial photograph taken after the storm. An aerial view of the Station One section reveals the power of the hurricane's wind and waves (left). Homes were stripped of their shingles, and some were shifted off their foundations. (Above, courtesy of Elizabeth King; left, courtesy of the Cape Fear Museum.)

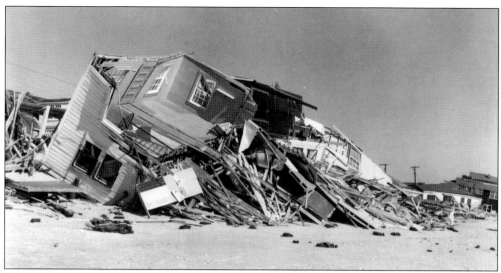

Those who returned to Wrightsville Beach after Hazel were astounded at the extent of the damage they found. Many beachfront homes appeared as though bombs had detonated near them. Seawater weighs approximately 1,730 pounds per square yard, and coupled with the destructive force generated by the hurricane's waves, it is not hard to imagine how oceanfront structures might have been broken open in such a dramatic fashion. Within some of the hardest hit structures, appliances, mattresses, bathtubs, and other furnishings could be seen dangling from third-story rooms. (Above and below, courtesy of the *News and Observer.*)

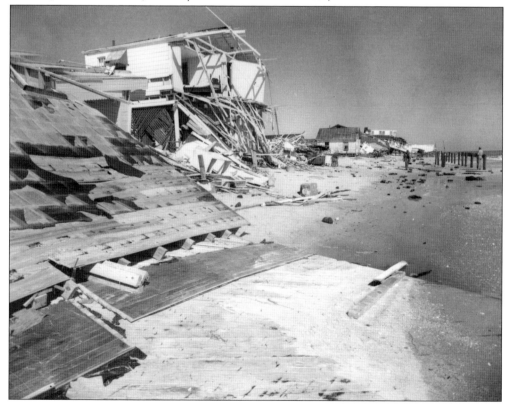

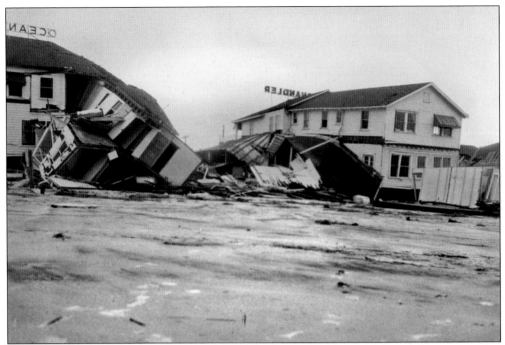

Wrightsville's oceanfront landmarks were pounded by Hazel's tide. Hotels, bathhouses, and other businesses were damaged and destroyed (above). One of the largest of these was the Carolina Yacht Club (below), which was heavily damaged and left in a twisted shape. The club was formed by yachtsmen back in 1853 and is still active today, with nearly 1,000 members. The Carolina Yacht Club was destroyed by a hurricane once before, in October 1899. That structure was later torn down, and the new Carolina Yacht Club was constructed using some of the same timbers. After Hazel, the club was rebuilt again. (Above and below, courtesy of the Cape Fear Museum.)

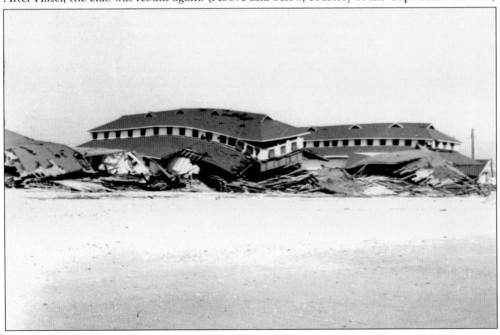

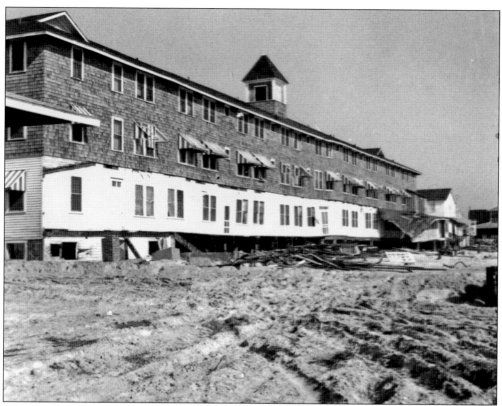

The popular Ocean Terrace Hotel on Wrightsville Beach (above) was hit hard by Hazel's wind and tides, but the main portion of the structure fared pretty well. First opened in 1897 as the Seashore Hotel, the Ocean Terrace was among the oldest and largest buildings on the beach. Operators once promoted its "250 feet of oceanfront verandas," but after Hazel, all facilities on the ocean side were swept away. Other oceanfront structures up and down the beach faired much worse. Through some sections, second-row cottages became front row (below). (Above, courtesy of the Cape Fear Museum; below, courtesy of the News and Observer.)

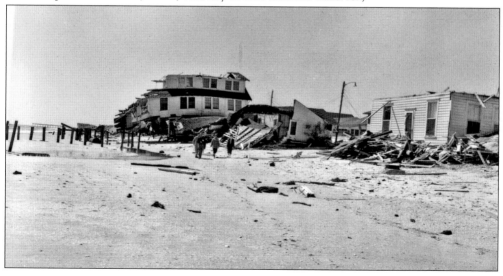

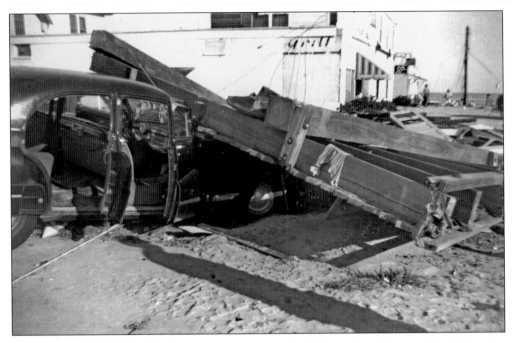

Deep sand filled every paved street in Wrightsville Beach after Hazel, and automobiles left on the island were knocked around like toys. These cars were left stranded and crushed near the Young Apartments. Some nearby structures lost their roofs completely, and large sections of roofing and decking floated into the streets, landing on cars and smashing storefront windows. One resident described the aftermath on Wrightsville as "resembling a Hollywood set on the scene of a disaster movie." (Above and below, courtesy of the Cape Fear Museum.)

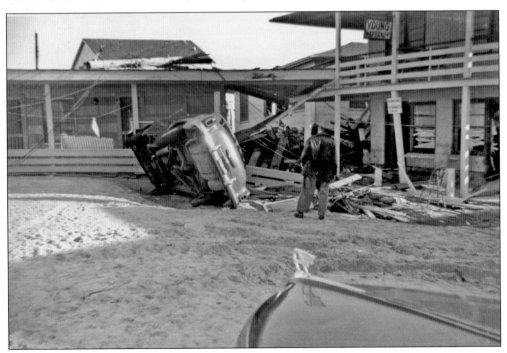

The Wrightsville Beach water tower survived Hurricane Hazel's ferocious winds intact. City workers tried to fill the tank as best they could in the hours before the storm to give it stability. But the cottages and other structures in the vicinity of the tower suffered heavy damages. Just under the tower was the Wrightsville Beach town hall and police station, along with a lifeguard station. It was there in the police station that Mayor Michael Brown and Chief Everett Williamson set up their command to coordinate the evacuation of residents and then later to ride out the hurricane. (Right and below, courtesy of the Cape Fear Museum.)

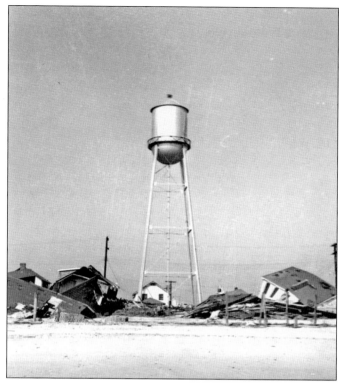

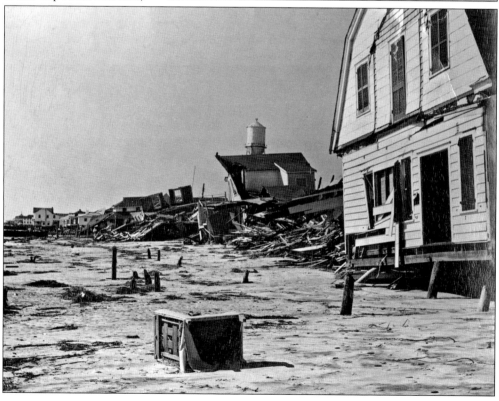

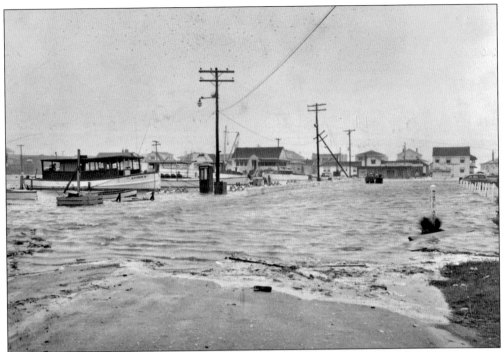

As the flooding began on Wrightsville Beach early on the morning of October 15, waters rose rapidly on the ocean beach and on the sound side as well. Motts Channel poured onto Island Drive, and Banks Channel rose into the streets throughout neighborhoods in Wrightsville Beach and Harbor Island. Docks were submerged and roads were impassable until hours after the hurricane passed through. (Courtesy of the Cape Fear Museum.)

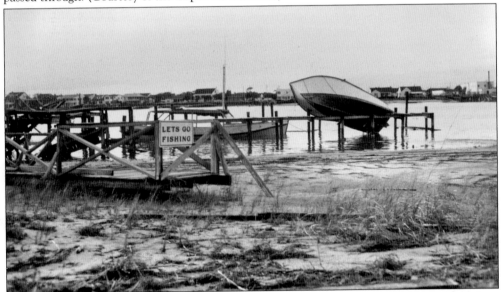

"Let's Go Fishing" was the suggestion made by a dock sign that somehow survived Hazel's fury. Along Banks Channel, scores of boats were tossed onto their docks or onto high ground, and some capsized and sank. Many boat owners did not have adequate time to travel to Wrightsville and secure their vessels before the storm. (Courtesy of the Cape Fear Museum.)

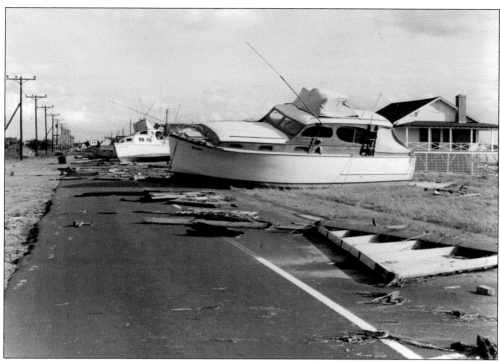

Hugh Morton's dramatic photograph of the Wrightsville Beach causeway after Hazel (above) suggests how much water must have covered the road during the storm. The Wrightsville fishing fleet broke from its moorings as the waters rose and ended up parked in random positions across the highway. Some boats crashed into telephone poles and houses, but many were essentially unharmed and were later hauled back to the water for fall fishing. The causeway needed to be cleared quickly so that residents could return in their cars to begin the inevitable cleanup of their once-glamorous beach resort. (Above, courtesy of Hugh Morton; below courtesy of the Cape Fear Museum.)

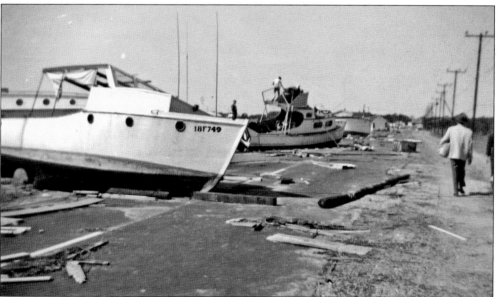

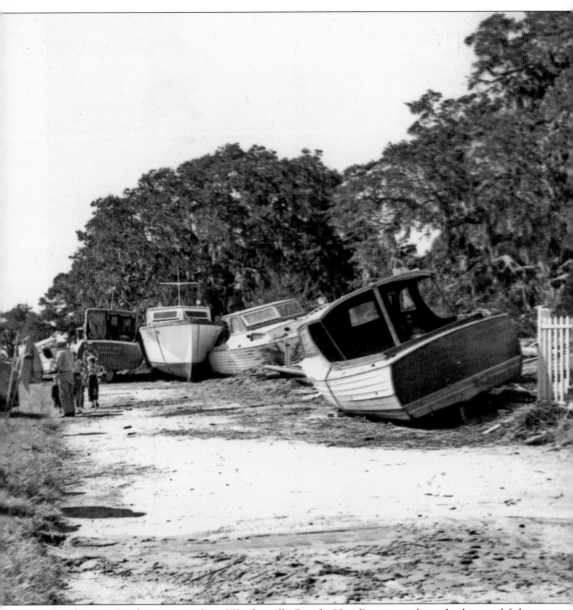

On the mainland just across from Wrightsville Beach, Hazel's storm tide pushed several fishing boats high onto Arlie Road, blocking that narrow lane. In the aftermath of the storm, there were stories told of several unusual finds among the storm-tossed debris along the banks of the sound. One newspaper reported that amusement games had washed across the island and were found days later still intact. Another story suggested that the cash register from Johnnie Mercer's Pier was found on the mainland near the Baby's Hospital after Hazel. (Courtesy of the Cape Fear Museum.)

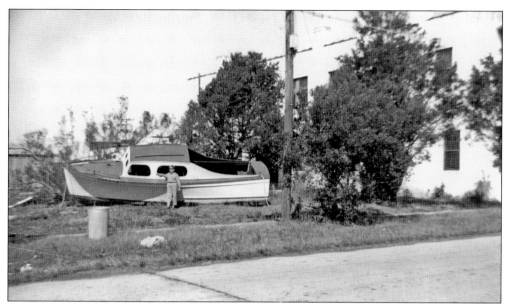

An unidentified Wrightsville Beach man stands with his boat in this photograph from the Cape Fear Museum. The county-operated museum, located in Wilmington, has one of the largest collections of Hazel photographs available and often presents lectures and exhibits about the most infamous of Carolina hurricanes. (Courtesy of the Cape Fear Museum.)

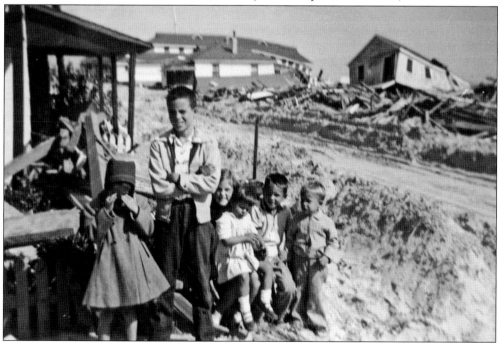

Wilmington resident Elizabeth King (far left) shared this photograph of herself, her brother, and four cousins. It was taken soon after Hazel and across the street from their great-grandfather's battered cottage. King's father, Michael Brown, was mayor of Wrightsville Beach during the storm, and her family's close connections to the island go back for generations. (Courtesy of Elizabeth King.)

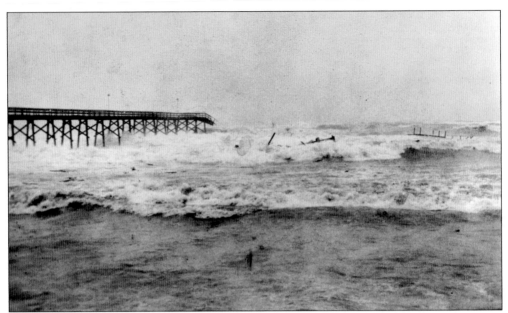

The Crystal Pier on Wrightsville Beach was one of two early fishing piers built on the island. Constructed in 1938 and opened as the Mira-Mar Pier, the 1,000-foot-long pier was built of costly cypress. It was later renamed the Luna Pier and then the Crystal Pier. Like almost every other pier in southeast North Carolina and northeast South Carolina, the Crystal Pier was knocked down by Hazel's massive waves, as seen in the photograph above. The pier house was about all that remained after the storm. Rebuilt after Hazel, the pier was heavily damaged again by Hurricanes Bertha and Fran in 1996. Today it remains unrepaired but is home to the popular Oceanic Restaurant. (Above, courtesy of the Cape Fear Museum; below, courtesy of the North Carolina State Archives.)

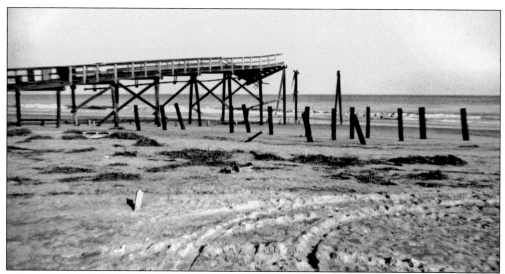

Johnnie Mercer's Pier (above), a longtime fixture on Wrightsville Beach, was washed away by Hazel's raging storm tide. Opened in the mid-1930s as the Atlantic View Pier, the 912-foot structure buckled during the 1954 storm, and its broken pilings and deck boards swept into town, battering nearby structures and filling streets with debris (below). Mercer rebuilt after Hazel, and the family eventually sold the pier to the Johnson family in 1968. In 1996, Hurricanes Bertha and Fran wiped it out again. When it reopened again in 2002, Johnnie Mercer's Pier emerged as a more durable structure—the first all-concrete ocean pier on the North Carolina coast. (Above and below, courtesy of the Cape Fear Museum.)

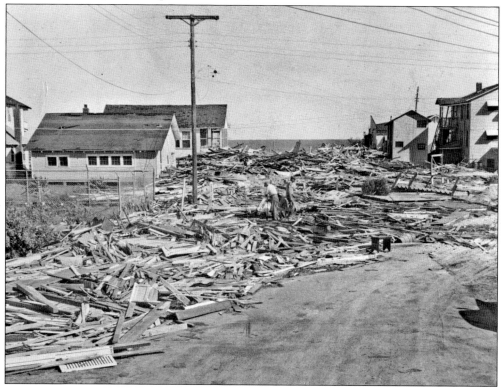

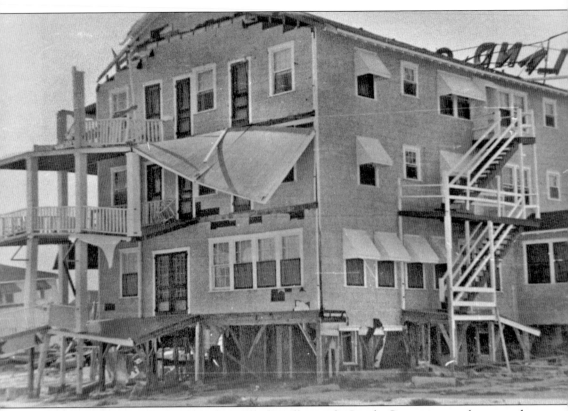

Among the heavily damaged hotels on Wrightsville was the Landis Cottage, a popular resort that suffered extensively during Hazel's passing. Through the 1940s and 1950s, the Landis advertised all the deluxe features beach vacationers were looking for: "Oceanfront views, private porches, air-conditioned rooms, private baths, and ample parking." A short pier and gazebo on the ocean side disappeared during the storm. The broad verandas that wrapped around the structure on three floors were ripped away by the hurricane's winds, and surging waters swept through the first-floor rooms and restaurant. (Courtesy of Bill Creasy.)

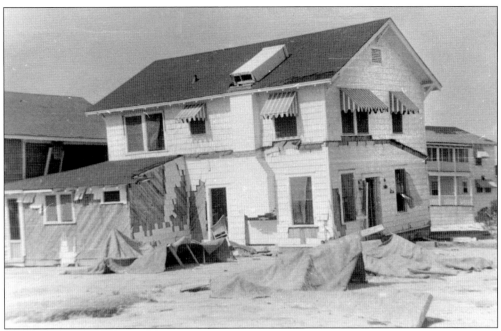

Even elevated oceanfront cottages on Wrightsville Beach were no match for the high waters and fierce winds of Hurricane Hazel. Winds whipped away attached awnings, porches, and roof sections on some homes (above) and toppled dozens of brick chimneys. Some homes floated off their supports and were submerged by the tide, leaving lower floors washed out and partially missing (below). Hurricanes like Hazel and the others that followed during the 1950s and 1960s led state and local governments to improve building codes in coastal counties around the country, making beach homes more durable. (Above, courtesy of Bill Creasy; below, courtesy of the Cape Fear Museum.)

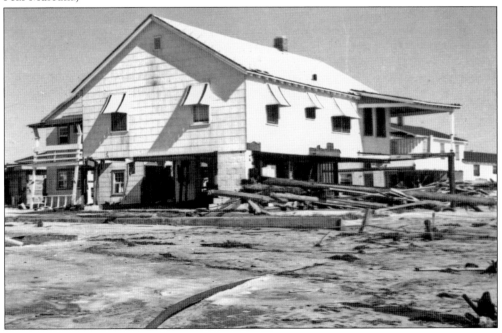

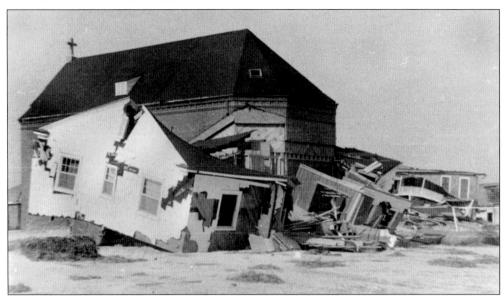

Another landmark on Wrightsville heavily damaged by Hazel was the St. Therese Catholic Church on South Lumina Avenue. The church was founded in the early 1900s inside a small beach cottage. The congregation grew, and a large brick structure was built in 1944. Hazel did extensive damage to the church and rectory, but they were rebuilt the following year. Renovated again in recent years, St. Therese today serves more than 400 families on Wrightsville Beach. (Courtesy of Bill Creasy.)

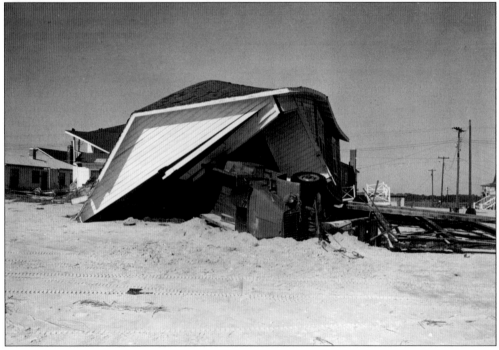

On Wrightsville Beach, a ¾-ton weapons carrier truck from Camp Davis, North Carolina, was no match for Hazel's fury. Likely overturned by large waves, the truck was found almost covered by a collapsed house off Lumina Avenue. (Courtesy of the Cape Fear Museum.)

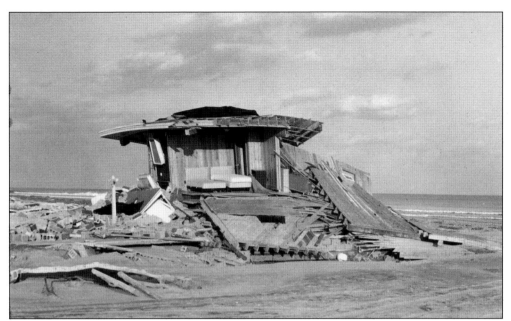

Hazel was moving rapidly toward the north when it struck the Carolina coast, and its tightly wound eye tracked inland near Raleigh. But the size and intensity of the storm delivered hurricane-force winds and record tides northward up the North Carolina coast, well beyond the region of immediate landfall. On low-lying Topsail Island in Onslow County, Hazel caused beachfront destruction very similar to that seen on Wrightsville and Carolina Beaches. The island's only bridge was washed away, and a U.S. Marine Corps amphibious "duck" was the only form of transport onto the island for days. Topsail Beach lost 210 of its 230 homes, leaving damages totaling $2.5 million (in 1954 dollars). (Above and below, courtesy of the Cape Fear Museum.)

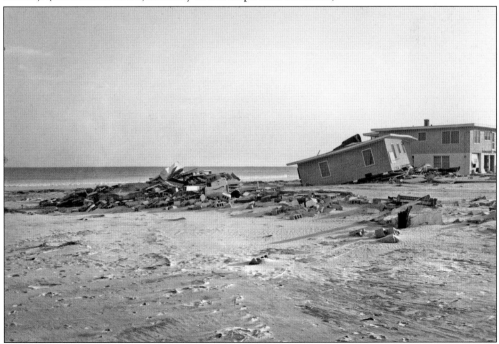

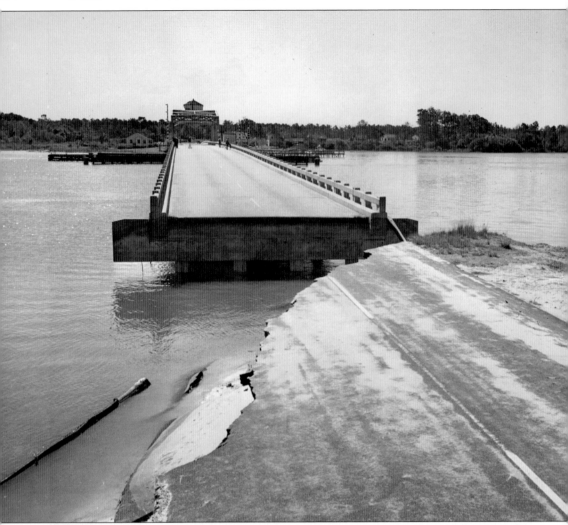

Hurricane Hazel's record-breaking storm surge was not just a problem for the oceanfront beaches of North and South Carolinas' barrier islands. Large portions of the region's sounds and rivers also rose to record levels, flooding farms, homes, and businesses miles from the ocean shore. The causeway at the Sneads Ferry Bridge over the New River in Onslow County, North Carolina, was one victim, washed out by storm surge–induced high water. In North Carolina, high waters also flooded the banks of the Cape Fear River, Topsail Sound, Virginia Creek, Stump Sound, Bogue Sound, Pamlico Sound, and the Neuse and Pamlico Rivers. (Courtesy of the Cape Fear Museum.)

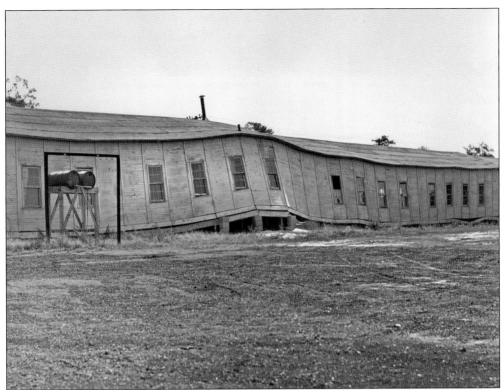

Though it was many miles east of the path of Hurricane Hazel, the Cherry Point Marine Corps Air Station, near Havelock, North Carolina, was buffeted by high winds that peeled away asphalt shingles and buckled walls in storage buildings. Though it is situated in a somewhat protected location surrounded by the tall pines of the Croatan National Forest, Cherry Point Marine Corps Air Station was the most reliable source for wind-speed data in the Carteret County region at the time. During Hazel, a maximum gust of 88 miles per hour was recorded, although just a few miles away at Morehead City gusts were thought to have exceeded 100 miles per hour. (Above and right, courtesy of the Cape Fear Museum.)

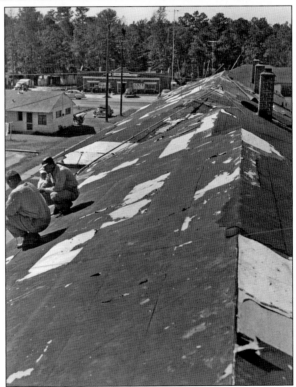

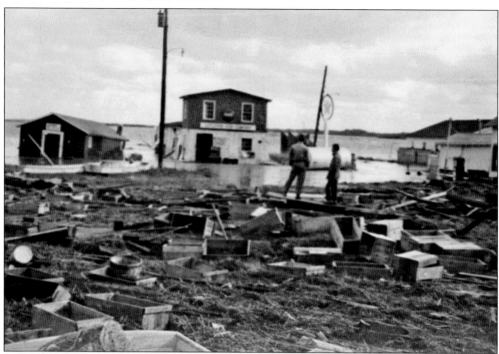

Swansboro, North Carolina, at the mouth of the White Oak River, has a long history with hurricanes. The flooding brought by Hazel's tides surprised many residents, however. Though the storm tracked well to the south and west, high water covered Front Street, washing away docks and fish houses, flooding shops and restaurants, and floating large boats up onto high ground. As with most other coastal towns affected by the storm, large rafts of timber and debris choked the streets of Swansboro, giving area residents a huge mess to clean up in the days and weeks that followed the storm. (Above and below, courtesy of the North Carolina State Archives.)

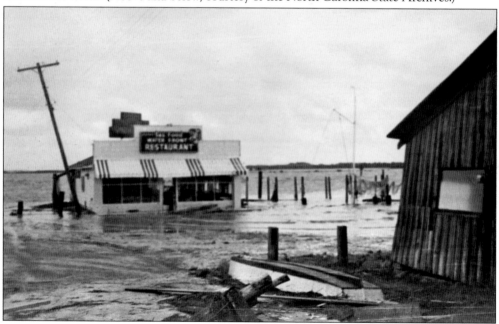

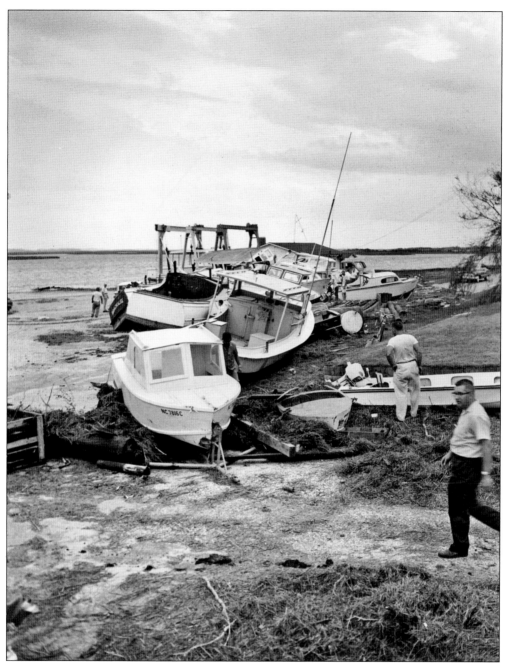

When the United States is threatened by hurricanes today, coastal residents have the benefit of ample warning, thanks to the reconnaissance work and timely forecasts of the National Hurricane Center in Miami. With this warning that typically comes days before a storm's arrival, boat owners often relocate their craft to upland creeks that offer some protection from wind and waves. Some boats can be removed from their berths onto trailers that can be driven to high ground. But during Hazel there was little warning, and many had no idea the hurricane would bring the high water that it did. As a result, scores of boats in Swansboro floated over their docks and into the streets of town. (Courtesy of the North Carolina State Archives.)

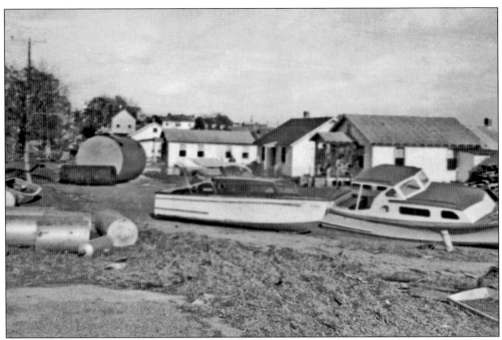

After Hazel passed, Swansboro residents came down to the waterfront to see what impact the storm had on their city. Everyone knew about the howling winds and the downed trees and power lines, as they saw ample evidence of those throughout their neighborhoods. But when they arrived along the waterfront, they were shocked to see large shrimp boats parked in the streets. Hazel's storm tide carried all sizes of boats into the town, but it also floated several large fuel tanks away from the docks and onto high ground. (Above and below, courtesy of the North Carolina State Archives.)

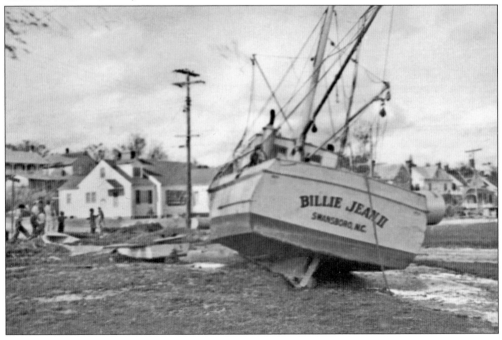

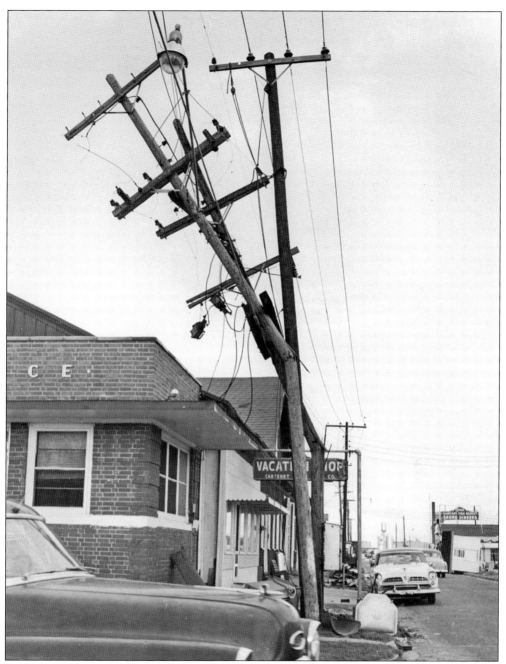

High winds whipped the Morehead City, North Carolina, waterfront during Hazel, snapping this telephone pole on Evans Street. Like much of the rest of eastern North Carolina, power was out for Morehead City residents. But after the storm, a nearby Carolina Power and Light generator was cranked up and used to furnish electricity to the waterfront Sanitary Restaurant (background), which became the only feeding station available for local residents and relief workers. Of course, the Sanitary had to be cleaned up first because during Hazel's storm tide, former owner Tony Seamon Jr. recalls seeing "chairs and stools floating around inside the restaurant." (Courtesy of the North Carolina State Archives.)

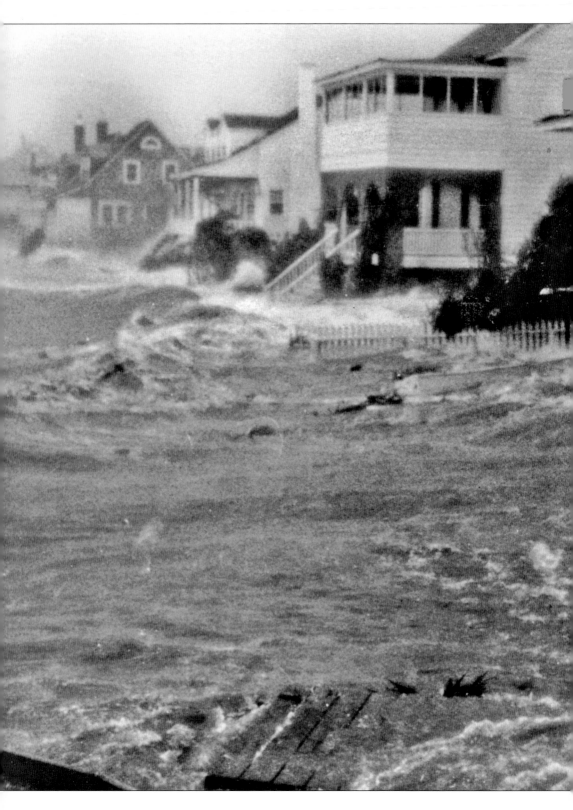

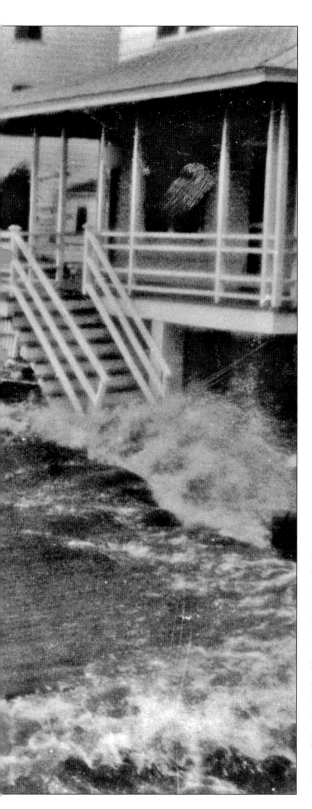

Hurricane Hazel's arrival in Carteret County, North Carolina, was not a direct hit because the storm tracked well to the west. But its impact was nevertheless dramatic, and it left area residents comparing Hazel to the great storms of the past, like the infamous unnamed hurricanes of August 1899 and September 1933. Winds gusted above 100 miles per hour, and a powerful storm tide rolled onto Atlantic Beach. But in this photograph, taken from the old Atlantic Beach bridge, it was the waters of Bogue Sound that flooded the front lawns of homes along Evans Street in Morehead City. (Courtesy of Clifton Guthrie.)

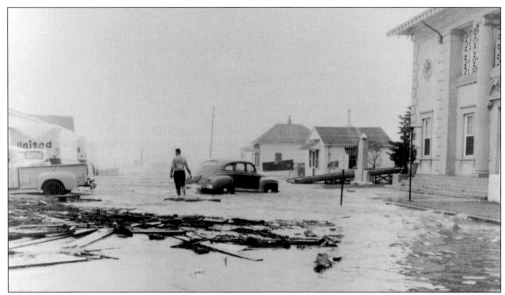

The full moon high tide that caused Hazel's storm surge to lift even higher was a problem for all the waterfront areas surrounding Morehead City and Beaufort, North Carolina. The tide lifted over the Morehead docks early on the morning of October 15 and continued rising throughout the day. It was not until mid-afternoon, when winds switched around to the west, that waters began receding throughout the region. Floodwaters covered Eighth Street in Morehead City (above) and washed boats and fuel tanks across Shackleford Street. (Above and below, courtesy of the *Carteret County News-Times*.)

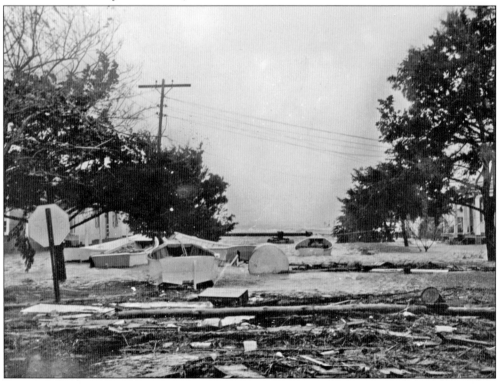

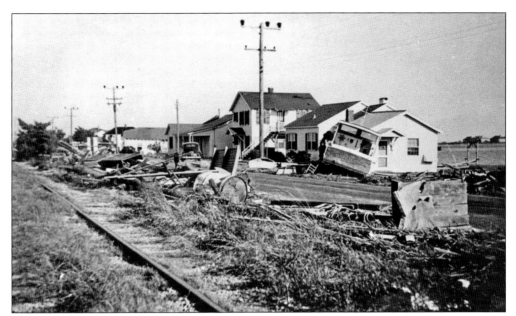

Hazel's storm tide smashed docks and lifted boats up and over the Morehead-Beaufort causeway (above). In Morehead City, Beaufort, and other fishing communities in "Down East" Carteret County, scores of fishing boats were sunk, wrecked, or otherwise washed out of their basins and into streets, yards, and forests. Among them was the fishing boat below, sunk along the Morehead City waterfront. (Above, courtesy of the *Carteret County News-Times*; below, photograph by Jerry Schumacher, courtesy of the Carteret County Historical Society.)

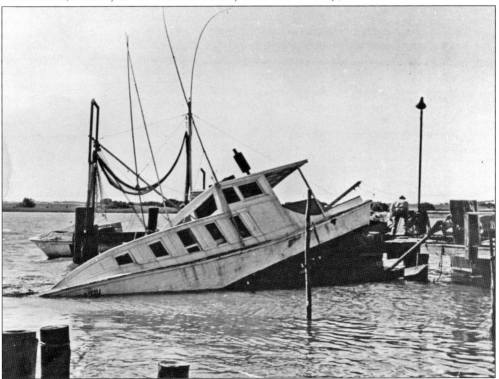

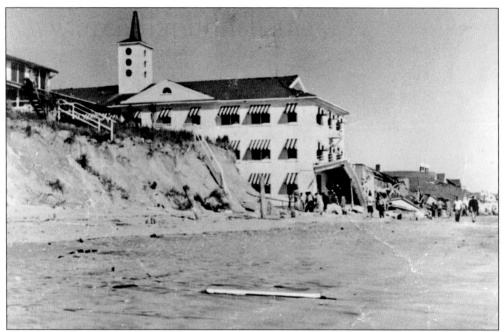

Heavy beach erosion is expected along surrounding coastal islands when major hurricanes come ashore. Hazel was no different, and its record-setting storm surge was devastating to the dunes and beach profiles of the entire coastline from Murrells Inlet, South Carolina, to Cape Lookout, North Carolina. As far north as Atlantic Beach, North Carolina, Hazel's storm surge was estimated at 8 feet. Bogue Banks, the island that includes Atlantic Beach, Pine Knoll Shores, and Emerald Isle, was washed over in two locations. In these photographs, heavy dune erosion can be seen in Atlantic Beach near the Ocean King Hotel (above) and along Ocean Ridge Drive (below). (Above and below, courtesy of the *Carteret County News-Times*.)

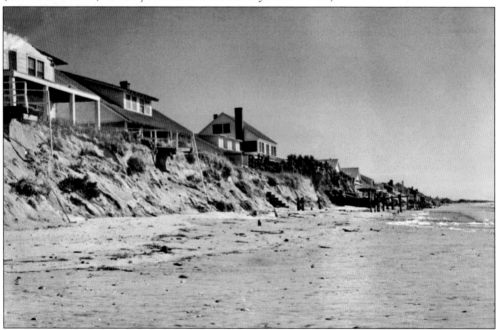

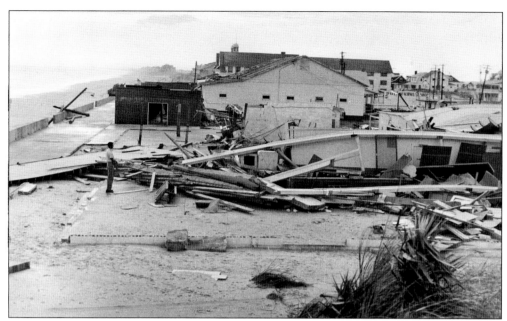

Hurricane Hazel's storm surge pounded the boardwalk area of Atlantic Beach to rubble. Waves estimated at nearly 20 feet washed away a portion of the Atlantic Beach Hotel. On the other end of the boardwalk, waves washed through the lobby of the Ocean King Hotel, undermining the building's foundation. The area around the boardwalk's popular pavilion (above) was also heavily damaged. (Courtesy of the North Carolina State Archives.)

Because Hazel arrived in mid-October, most of the bathhouses, soda shops, and rental homes on Atlantic Beach were boarded up for the winter when it arrived. Like most of the barrier beaches affected by the storm, no large-scale evacuations were necessary. But even if Hazel had struck during the summer of 1954, the seasonal population of vacation spots like Atlantic Beach, Wrightsville Beach, Carolina Beach, and Myrtle Beach would have only been a small fraction of what might be expected during the summer season today. (Courtesy of Pete McSorely.)

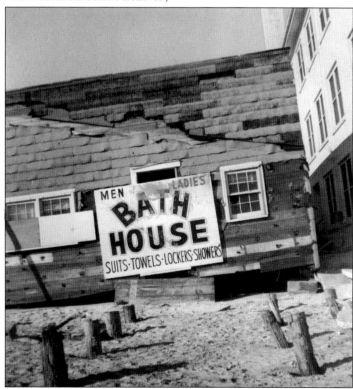

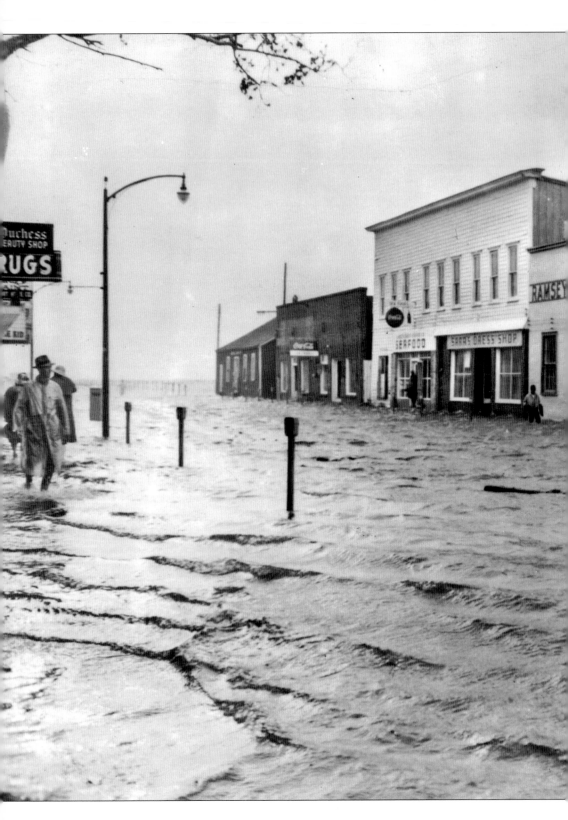

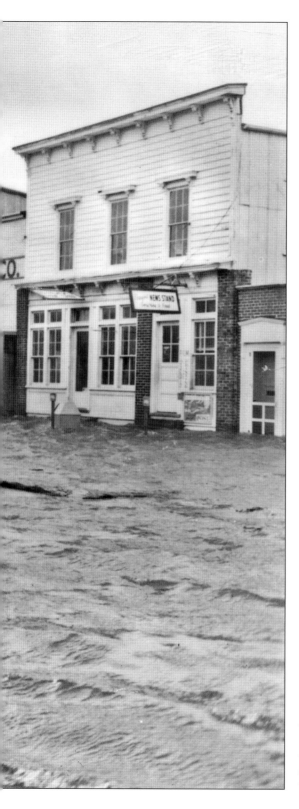

Front Street in Beaufort, North Carolina, was also submerged in Hurricane Hazel's relentless storm tide, with the peak level arriving at 11:15 a.m. Docks along the waterfront disappeared under the waves, and surging waters were waist-deep in scores of shops through the business district. Grocery stores that residents depended on for food suffered heavy losses, and temporary food shortages were reported in local newspapers. East of Beaufort, the North River Bridge was washed away. It was the only link to the mainland for many "Down East" residents, and fortunately it was repaired shortly after the storm. (Courtesy of the *Carteret County News-Times*.)

The combination of Hazel's gusting winds and flooding tides brought considerable destruction to Morehead City, the most seen in that area since the September 1933 hurricane. Along the waterfront, several fish houses, a waterfront home, and the town's skating rink were washed from their foundations. Floodwaters filled the basement of the Morehead City hospital, and fire trucks were brought in to pump the water out. Meanwhile, nurses worked frantically in waist-deep water to move patients to higher floors and salvage medical equipment. In addition to the flooding, high winds peeled back metal roofs and toppled chimneys throughout town, leaving large sheets of crumpled tin and other debris scattered in the streets. This photograph, taken along Evans Street, shows some of the wind-damaged structures. (Courtesy of the *Carteret County News-Times*.)

Three

INLAND AND NORTHWARD

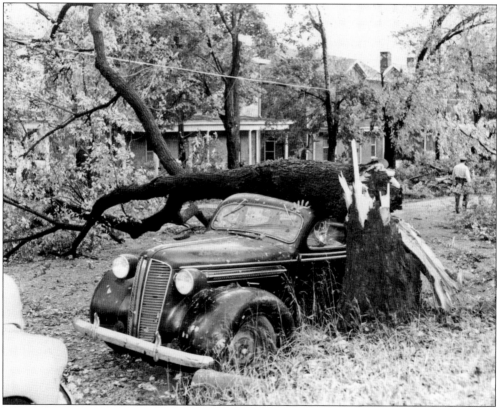

Often when people think about hurricanes, they immediately think about the destructive forces of waves and wind along the coast. But hurricanes are not just coastal affairs, as Hurricane Hazel demonstrated when it tore through the inland portions of North Carolina, Virginia, Maryland, Pennsylvania, New York, and Ontario, Canada, in 1954. Hazel's winds were incredibly destructive miles from the shore, knocking down tobacco barns, peeling back roofs, toppling trees and power lines, and causing mayhem for millions of people across eight states. In virtually every city, town, and country crossroad in its path, huge trees were toppled as a testament to the storm's destructive power. (Courtesy of the *News and Observer*.)

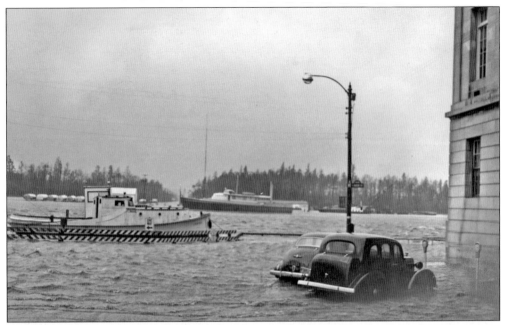

Hazel's storm surge was certainly destructive down at the coast. But even away from the ocean, the surge's effects were felt in places like Wilmington, where the Cape Fear River backed up and spilled over its banks. Along the waterfront, much of Water Street was underwater, as seen in the photograph above, taken at the foot of Market Street. Heavy damages were reported along the city's wharf area after the river spilled into storage warehouses, machine shops, and other businesses (below). The river flooding did not peak until early afternoon, several hours after the storm made landfall at the coast. (Above and below, courtesy of the Cape Fear Museum.)

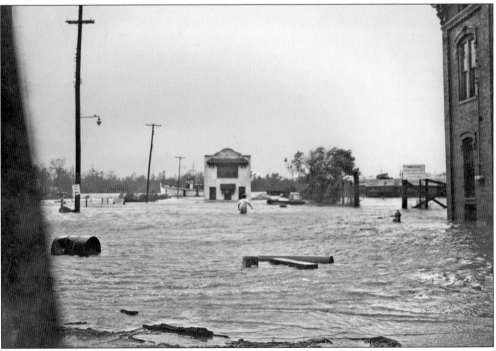

Once Hazel made landfall near the North Carolina–South Carolina border, its north-northeast track carried it through the heart of eastern North Carolina. The hurricane's center passed just east of Whiteville and Elizabethtown and on through Benson and Smithfield, carving a path between Raleigh and Rocky Mount on its way into Virginia. It accelerated as it spun inland, racing northward at 50 miles per hour and crossing the state in just five hours. Some of the heaviest wind damages occurred on the eastern side of the storm in cities like Goldsboro and Wilson. But even communities on the western side were blasted by Hazel's fierce winds, as evidenced in this photograph from a Fayetteville, North Carolina, car dealership. (Courtesy of the author.)

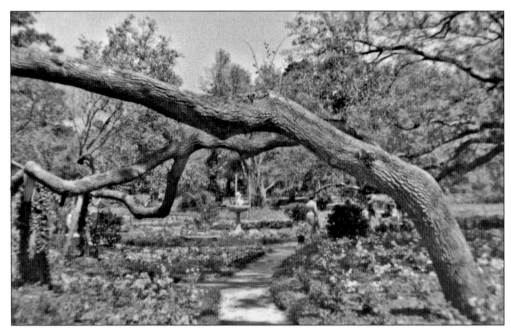

Winds gusting in excess of 100 miles per hour brought down millions of trees in eastern North Carolina during Hurricane Hazel's rapid spin through the state. It was not uncommon in many cities and towns for every single street to have been blocked by fallen trees. Pine trees were particularly vulnerable, and many were snapped in two, some 20 feet above the ground. But it was the loss of countless centuries-old hardwoods that was most heartbreaking to area residents. Live oaks suffered heavy losses in places like Wilmington's Arlie Gardens (above), and large hickory and elm trees were toppled in Wilson (below). (Above, courtesy of the Cape Fear Museum; below, courtesy of Raines and Cox Photography.)

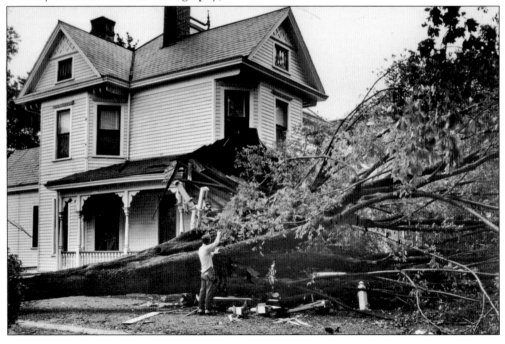

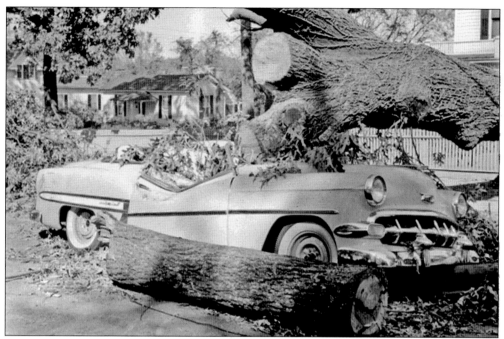

Chapel Hill News Leader editor and photographer Roland Giduz snapped these photographs of massive fallen trees in Chapel Hill, North Carolina, after Hurricane Hazel. Hazel toppled thousands of large oaks and other hardwoods throughout the Triangle, often dropping them on cars, homes, and power lines (above). Because chain saws were not as common as they are today, many trees had to be cut up by hand with large bow saws (below). Many Triangle residents who endured Hazel lived to experience a similar calamity during Hurricane Fran in 1996. Fran also cut through the Raleigh-Durham area and toppled millions of trees. (Above and below, photographs by Roland Giduz; courtesy of the North Carolina Collection, University of North Carolina Library at Chapel Hill.)

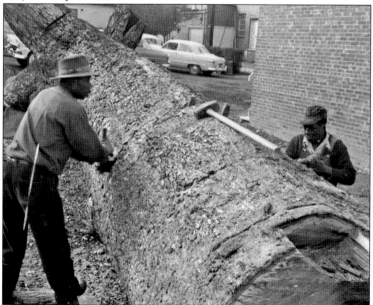

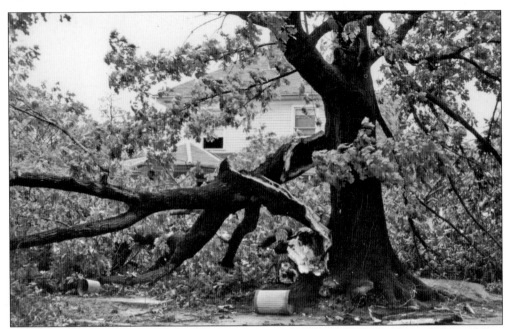

Though most communities along the Carolina coast did receive some advance warning of Hazel's arrival, forecasters and government officials did not anticipate the hurricane's inland track. North Carolina cities and towns along the storm's path were caught off guard by the ferocious winds that whipped through their streets. In most areas, schools were in session when the skies quickly darkened and the winds grew fierce. Not knowing any better, some schools released their students near the peak of the storm. To this day, the students still tell stories about their harrowing rides home along streets covered with fallen trees. These scenes in Wilson were typical of the destruction. (Above and below, courtesy of Raines and Cox Photography.)

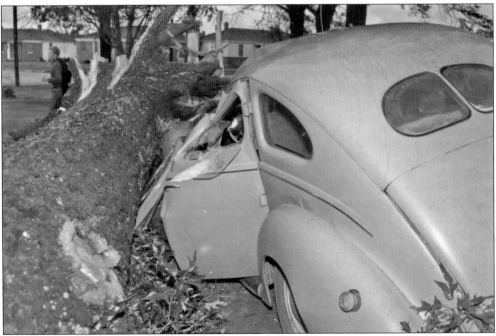

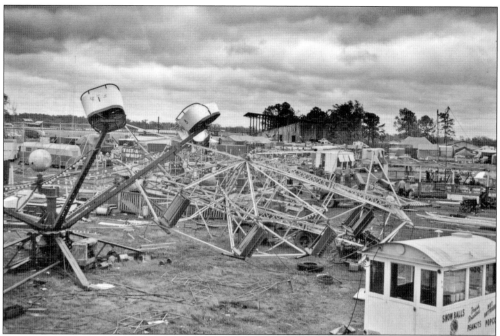

With no real warning of Hazel's approach, life across eastern North Carolina was proceeding as usual until the storm disrupted everyone's plans. Church banquets, high school football games, and county fairs were all on the schedule for this otherwise typical Friday in October. But as the Category 4 hurricane hit and raced northward, all plans changed. There was no time to prepare or cancel arrangements, instead everyone coped the best they could. Among the scenes of destruction was the Wilson County Fair, where gusting winds blew apart amusement rides and toppled tents and trailers. (Above and below, courtesy of Raines and Cox Photography.)

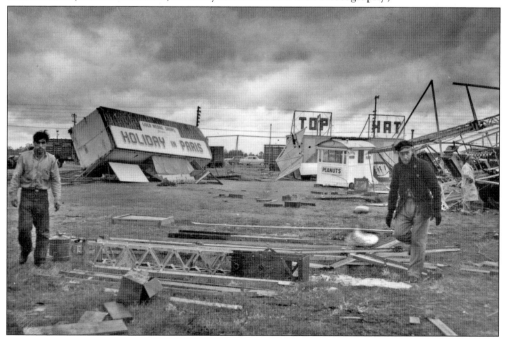

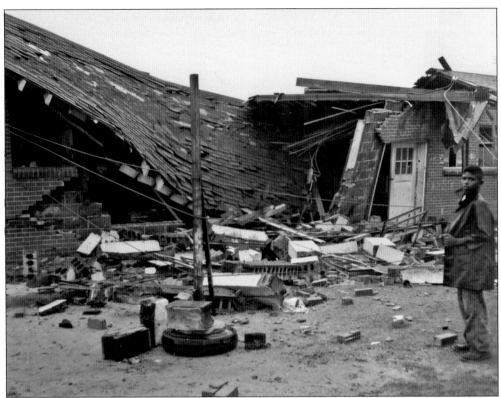

Agricultural losses across North Carolina were significant, although many crops like tobacco had already been harvested by mid-October when Hazel arrived. But in farms and fields across the eastern counties, Hazel's winds still caused substantial destruction. Farm buildings and barns were especially hard hit, as were the larger tobacco warehouses around Wilson (above). After the storm, some of the warehouses appeared undamaged at first, until workers found large mounds of crumpled metal scattered across the property—the twisted remnants of the warehouses' roofs (below). (Above and below, courtesy of Raines and Cox Photography.)

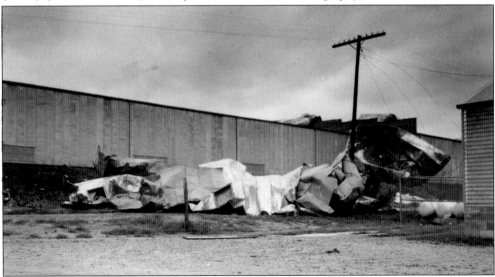

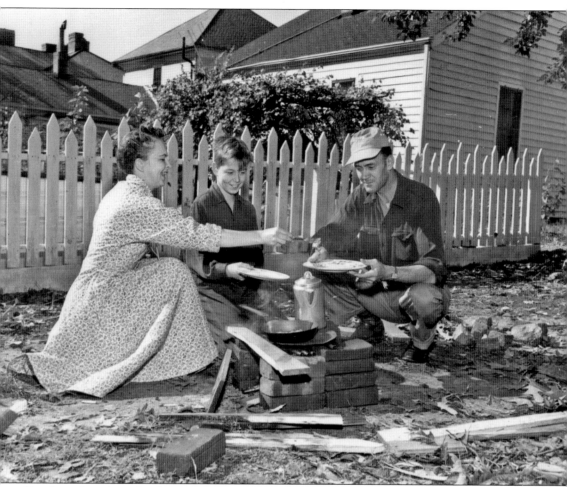

Hazel raced northward and passed slightly east of Raleigh, where the worst of the storm lasted just over one hour. Though it swept through the area quickly, its impact on families and businesses lingered for weeks. It was difficult to drive the streets because of the large number of downed trees and power lines. Many people stayed close to home, making repairs to their houses and clearing trees and limbs. Most residents near the hurricane's path were without electricity for several days. They adapted quickly, however, and cooked meals over campfires in their yards. (Courtesy of the *News and Observer*.)

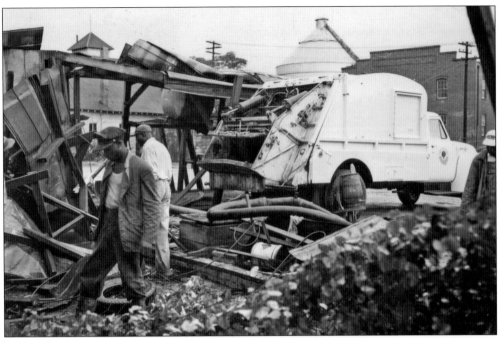

From the Brunswick County beaches to Wilson County (above) and Chapel Hill (below), a wide swath of eastern North Carolina was pounded by Hurricane Hazel. Cleanup efforts began immediately after the storm, and two of the greatest tasks were removing countless fallen trees and hauling away massive piles of debris. In many areas, the quantity of tree stumps and building debris was so great that large piles were burned, filling the skies with smoke that seemed to linger for weeks. And for the thousands of North Carolina residents who had fireplaces, there was ample firewood for several winters. (Above, courtesy of Raines and Cox Photography; below, photograph by Roland Giduz, courtesy of the North Carolina Collection, University of North Carolina Library at Chapel Hill.)

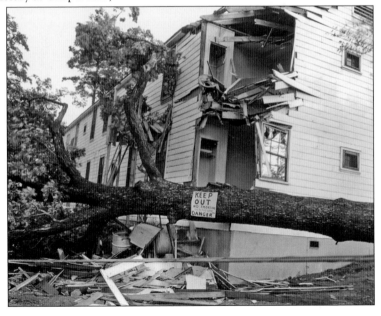

The cleanup and recovery that followed Hazel was much like that of other hurricanes, except that the storm's impact was spread over such a large region. Storm-tide flooding along the coast and record wind gusts across several states caused widespread destruction and put thousands to work on the cleanup effort. The storm's victims cleared their streets and yards, patched their homes, and dried out their flooded furnishings. (Courtesy of the North Carolina State Archives.)

Throughout the 1950s, hurricanes battered the Carolina coast, and after each one, loss of electrical power was one of the most critical recovery issues. Hazel was just one of several storms that caused outages in eastern North Carolina during this period. Line crews from Carolina Power and Light worked diligently to replace broken or toppled poles and wires. (Courtesy of the North Carolina State Archives.)

The highest wind gusts in North and South Carolina where Hazel came ashore may never be known. It is known that Hazel was a Category 4 at the time of landfall, and winds likely ranged from 120 to 140 miles per hour or more. As the storm raced inland, gusts above 100 miles per hour were known to have occurred hours after landfall. Many people do not realize that the force exerted by wind increases with the square of the wind speed—meaning that a wind of 120 miles per hour exerts four times the force of a 60-mile-per-hour wind. Thus the ability of the wind to cause damage increases exponentially as the winds get stronger. Snapped power poles were an example of this force in the aftermath of Hazel. (Courtesy of the North Carolina State Archives.)

Hazel swept quickly through North Carolina and raced into Virginia, where the storm's destructive winds continued. Over the next several hours, Hazel spun northward, setting new wind records in seven states. It moved into western New York, where it merged with a strong low-pressure system coming off the Great Lakes. The result was a catastrophic flood near Toronto, Ontario, which would ultimately become the greatest in Canadian history. (Courtesy of NOAA.)

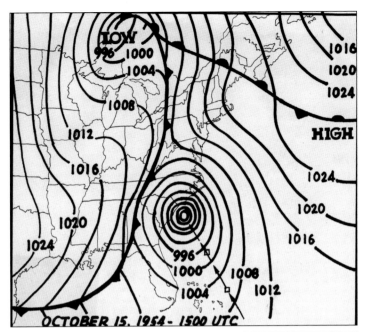

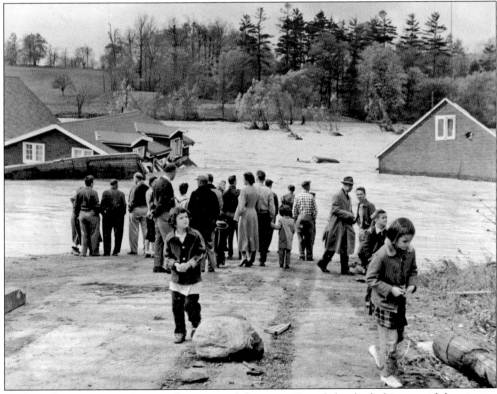

Far from the warm tropical waters that spawned the storm, Canada has had a history with hurricanes that mostly involves dying storms crossing the Maritime Provinces. Hazel was different, and its record-setting floods along the Humber River created lasting memories for those in the Toronto region who endured the storm. (Courtesy of the Weston Historical Society.)

Women pedestrians held their hats as they walked down the center of Eighteenth Street in Philadelphia on the Friday afternoon that Hazel struck. Behind them, workers from the Barclay Hotel are seen frantically taking down the framework of an entrance awning as the ladies pass. Hazel maintained considerable energy over land, and its winds were made even stronger by the storm's rapid forward momentum. New wind records included gusts measured above 100 miles per hour in Norfolk, Virginia; Salisbury, Maryland; Washington, D.C.; Philadelphia, Pennsylvania; and New York, New York. Some of those wind records still stand today. (Courtesy of the Temple University Urban Archives.)

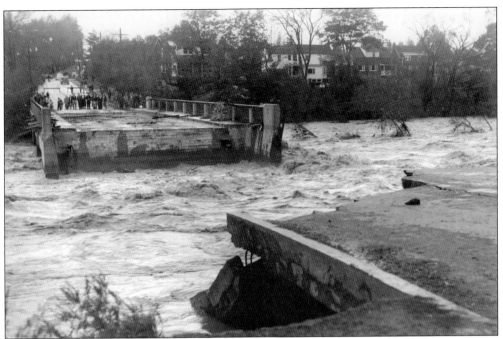

Hazel set rainfall records in addition to those set for wind. In North Carolina, 10 climate observation stations set new records for 24-hour precipitation. As the storm raced northward through Virginia, Maryland, Pennsylvania, and New York, the heaviest rainfall amounts were recorded on its western side. Some portions of western Pennsylvania and New York received up to 12 inches, and flash flooding swept away homes and livestock. But the greatest flooding was yet to come, in the Toronto area around the Don and Humber Rivers. Through the night of October 15 and morning of October 16, flash floods swept away several bridges over the Humber, including the Lawrence Avenue Bridge (above) and the Wadsworth Bridge (below). (Above and below, courtesy of the Weston Historical Society.)

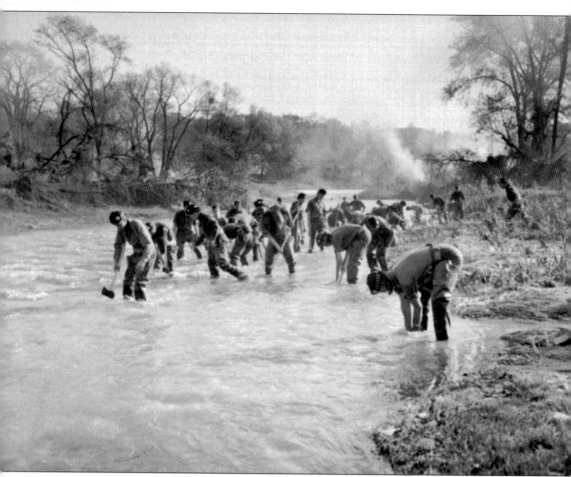

The tragic flash floods that hit the Humber River spilled into several neighborhoods, sweeping away homes, cars, and people. It took a day or so for authorities to fully understand the impact of the flood and how many lives might be lost. It turned out to be a horrible tragedy. The floods claimed 81 lives in the Toronto area, including five firemen who drowned during a rescue attempt and 32 sleeping residents on Raymore Drive—an entire block of homes—who died when a wall of water came down the Humber River. In this photograph, taken after the flood, the 48th Highlanders search for bodies down the river below the Dundas Street Bridge. (Courtesy of the Archives of Ontario.)

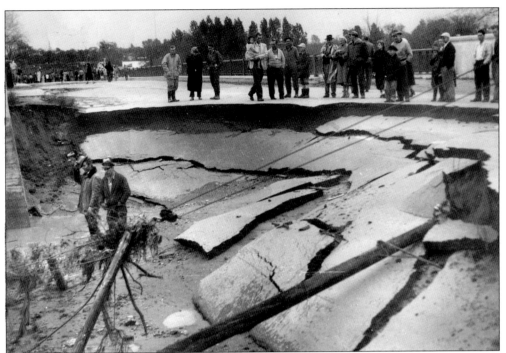

Because Hazel struck the Toronto area during the night, most streets and highways were not busy with traffic. Countless roadways and as many as 20 bridges were washed out by the tremendous flash flood that swept the area (above). One of the bridges lost was the Lawrence Avenue Bridge, seen here from the Weston side of the river (below). Once the floodwaters had subsided on the following day, nearby residents came down to the river to witness the destruction. Unfortunately, some found the bodies of storm victims that had been swept downstream. (Above and below, courtesy of the Weston Historical Society.)

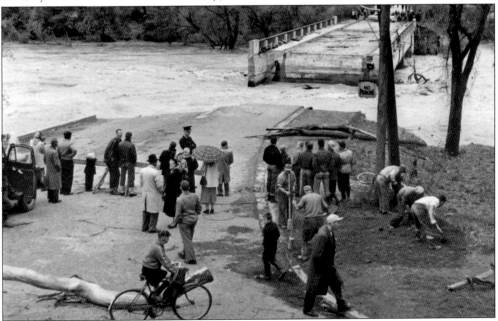

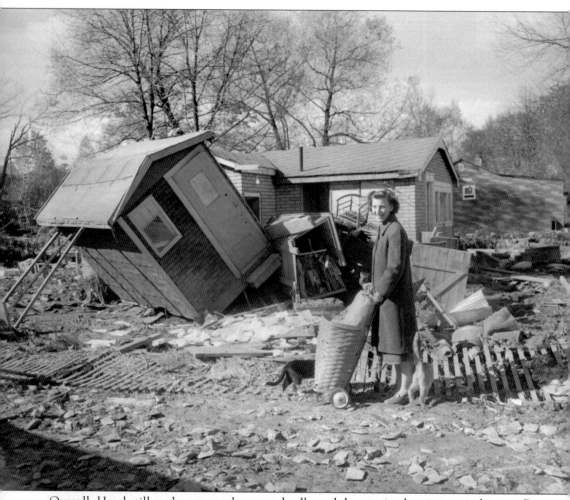

Overall, Hazel still ranks among the most deadly and destructive hurricanes in history. But for many, it will be remembered as the hurricane that would not die. For residents of Virginia, Maryland, West Virginia, Pennsylvania, Delaware, New Jersey, New York, and Ontario, Hazel's journey from the Carolina coast inland through the northeast was unlike anything experienced before. Though the death toll in the Carolinas was 20, there were recorded deaths in all of these states and 81 more in Canada. Hazel will long be remembered for its impact on people and communities over the span of some 2,000 miles, and meteorologists will continue to marvel at the force that it maintained while over land. (Courtesy of the Archives of Ontario.)

Four

HAZEL'S LEGACY

A Myrtle Beach police officer takes a break while working long hours in the aftermath of Hurricane Hazel. Like every other U.S. disaster, Hazel tested the responsiveness of governments on the federal, state, and local levels. During the 1950s, there was not much community preparedness for the threat of hurricanes. Many people were more concerned about a possible Russian attack. The term "emergency management" had not been invented, and most government agencies could only be reactive, rather than proactive, regarding hurricanes. But Hazel taught everyone in the Carolinas valuable lessons and helped prepare the region for other hurricane events that would arrive in the years to follow. (Courtesy of the *News and Observer.*)

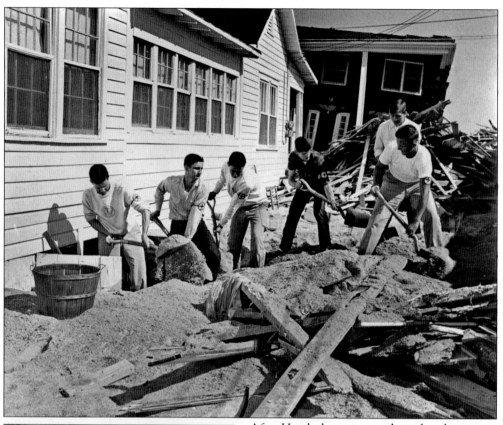

After Hazel, there was much work to be done cleaning up and repairing damaged homes. These college students, known as the "Dukes," volunteered their time with the American Red Cross and were sent to Carolina Beach. There they went to work digging sand out of a cellar in the home of a 60-year-old invalid. According to the Red Cross report, "Their greatest concern was her supply of winter fuel buried under the house." (Courtesy of the Cape Fear Museum.)

In the Carolinas today, coastal property owners know the high cost of insuring their homes is due to the threat of hurricanes. In 1954, when Hazel struck, it was a simpler time, and homeowners had just one relatively inexpensive policy or no policy at all. National flood insurance did not exist, and insurance rates were typically standardized. With thousands of homes destroyed and many more damaged, Hazel kept insurance adjusters busy for weeks. (Courtesy of the Archives of Ontario.)

Hurricane Hazel left many people along its path in need of food and housing. Just as they are today, two of the first on the scene after the storm were the Salvation Army (above, Wrightsville Beach) and the American Red Cross (below, Wilmington). In the days that followed Hazel, countless volunteers for these two groups served food, set up shelters, and provided clothing and other goods to the hurricane's victims. That tradition continues today, with large contingents of Salvation Army and Red Cross workers ready to help after each major hurricane disaster. (Above, courtesy of Bill Creasy; below, courtesy of the Cape Fear Chapter of the American Red Cross.)

A disaster relief headquarters was set up in Wilmington by the Red Cross, and staff and volunteers assisted hundreds of storm victims in the weeks following Hazel. In this Red Cross photograph, Mrs. Jim Glenn dresses her baby in new clothes paid for with Red Cross funds after she lost all her clothing and furnishings when her apartment was submerged by floodwaters. (Courtesy of the Cape Fear Museum.)

In Shallotte, North Carolina, a Red Cross Disaster Registration office was opened to help people in western Brunswick County. In this photograph, a Red Cross worker assists a woman made homeless by Hazel's record coastal flood. Caseworkers interviewed each victim to determine how to distribute available food, clothing, housing, and cash. (Courtesy of the Cape Fear Museum.)

In North Carolina alone, Hazel's toll was high. There were 19 people killed, 200 injured, 15,000 homes or other structures destroyed, 39,000 structures damaged, and an estimated $136 million in property losses. The economic impact on families was great too, as many were out of work because businesses closed after the storm. Many of these families lined up for assistance at the Red Cross registration offices. (Courtesy of the Cape Fear Museum.)

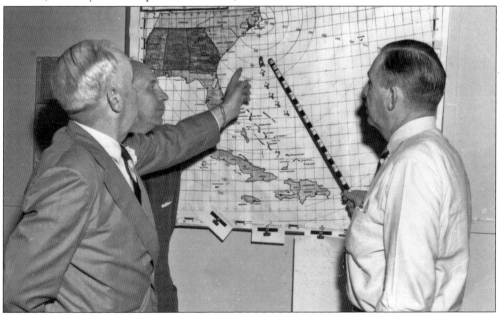

Luther H. Hodges (far left) was lieutenant governor of North Carolina when Hazel struck in October 1954, but he had to fill in for the state's governor, William B. Umstead, who had been ill and was hospitalized during the storm. Hodges became governor when Umstead passed away the following month. He then took a special interest in the next round of hurricanes that approached the Carolinas in the summer of 1955. (Courtesy of the *News and Observer*.)

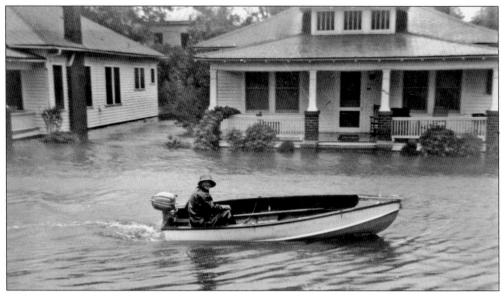

Less than one year after Hazel left its mark on the Carolinas, more hurricanes spun across the region and added insult to injury. The 1955 season delivered three hurricanes within six weeks: Connie, Diane, and Ione all hit the North Carolina coast, an unprecedented event in the state's recorded history. Connie was a Category 3, Diane a Category 1, and Ione a Category 3, and Connie and Diane were only five days apart. Creeks and rivers were already filled when Hurricane Ione came ashore near Morehead City on September 19, 1955. In the 42-day period from August 11 to September 20, a rainfall total of 48.90 inches was recorded in Maysville, North Carolina. All that rain resulted in unprecedented flooding in much of the east, with disastrous results in cities like New Bern, Washington (above), and Belhaven (below). (Above, courtesy of Clyde Roberson; below, courtesy of Roy Hardee.)

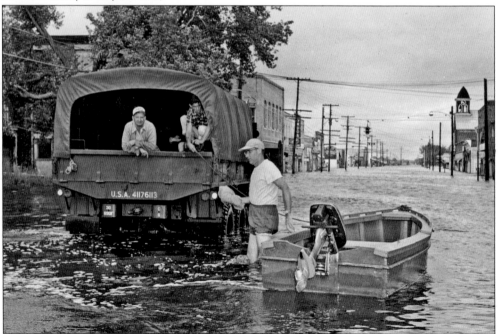

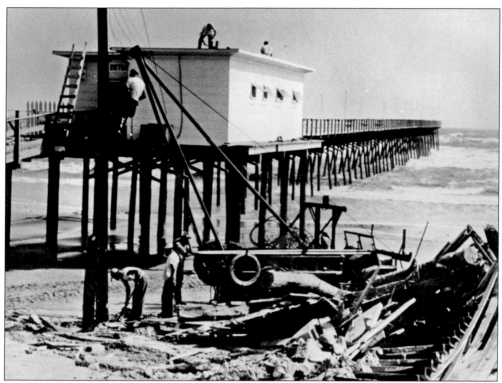

Like this one in Atlantic Beach, all of North Carolina's popular fishing piers were rebuilt after the hurricanes of the 1950s, and most were built back taller, longer, and stronger. The North Carolina coast had a total of seven piers in 1950, but by 1960, that number had grown to 30. The number peaked at 35 in 1985, but today less than 20 remain. Privately owned piers remain vulnerable to hurricanes and nor'easters, as well as to the pressures of coastal real estate development. (Photograph by Jerry Schumacher; courtesy of the Carteret County Historical Society.)

Hurricane Hazel in 1954 was followed by a string of hurricanes along the Carolina coast that ended with Hurricane Donna in September 1960. Through this active period, the region earned the nickname "Hurricane Alley." After Donna, a quiet period followed in which there were few hurricanes during the next two-and-a-half decades. The next significant hurricanes in the region were Diana in 1984, Gloria in 1985, and Hugo in 1989. (Photograph by Jerry Schumacher; courtesy of the Carteret County Historical Society.)

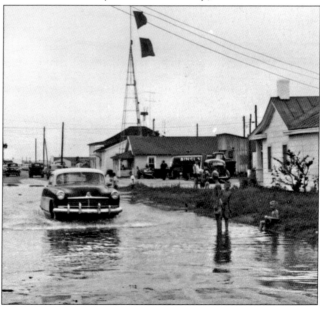

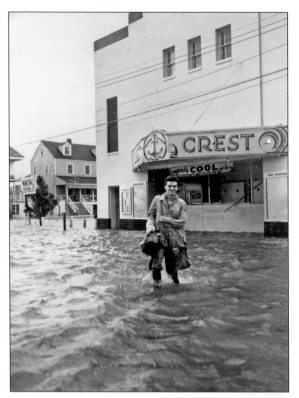

People in South and North Carolina who lived through Hazel often cannot resist sharing their stories. When the subject of hurricanes arises, they like to retell where they were and what they saw as the storm rolled through their neighborhoods. Much of what is known about great storms is shared this way, passed down from one generation to the next. (Courtesy of the North Carolina State Archives.)

On October 15, 2007, on the 53rd anniversary of Hazel, a historical marker was unveiled on Oak Island to commemorate the storm. Gathered along the roadside with a handful of survivors, media, and guests, Jerry Helms (left), the honeymooner who floated with his wife on a mattress, and the author (right) uncover the plaque. The marker will help visitors remember the local significance of one of the greatest storms in history. (Courtesy of the *State Port Pilot*.)

ABOUT THE AUTHOR

Hurricane historian Jay Barnes grew up on the North Carolina coast and has spent the last 20 years researching, writing, and lecturing about our nation's hurricane history. Born in Southport, he now lives in Pine Knoll Shores, North Carolina, where he has worked with the North Carolina Aquariums for more than 30 years. Though he is not a trained meteorologist, his studies have focused on hurricanes—from an historical perspective. This interest developed over the years after he grew up hearing stories about the Carolinas' greatest hurricane of the era: Hurricane Hazel in 1954.

Jay has written extensively about hurricanes, including *North Carolina's Hurricane History* (UNC Press), now in its third edition, and *Florida's Hurricane History* (UNC Press), in its second edition. These are comprehensive chronologies of the hurricanes that affected these states, from the days of the first European explorers to the present. Each book weaves together meteorological details with survival stories and dramatic photographs. After Hurricane Floyd devastated much of his home state in 1999, Jay teamed with former state treasurer Richard Moore to produce *Faces From the Flood* (UNC Press), a heavily illustrated oral history of the great flood that was later made into an award-winning television documentary. Jay also writes occasionally for national and regional magazines like *Weatherwise*, *Our State*, and *Wildlife in North Carolina*.

His expertise on U.S. hurricanes has made him a frequently requested lecturer for a variety of conferences and symposiums around the nation. In addition, he is a regular contributor to video documentaries that investigate the nature and history of Atlantic hurricanes. These have included productions for the *History Channel*, the *Weather Channel*, the *Discovery Channel*, the *Learning Channel*, *National Public Radio*, MSNBC, the *NBC Nightly News*, the *CBS Evening News*, and others.

www.arcadiapublishing.com